HAJISÍ DÍGÍÍ DAHIISTŁǪ́ BIIHJI NIŁ

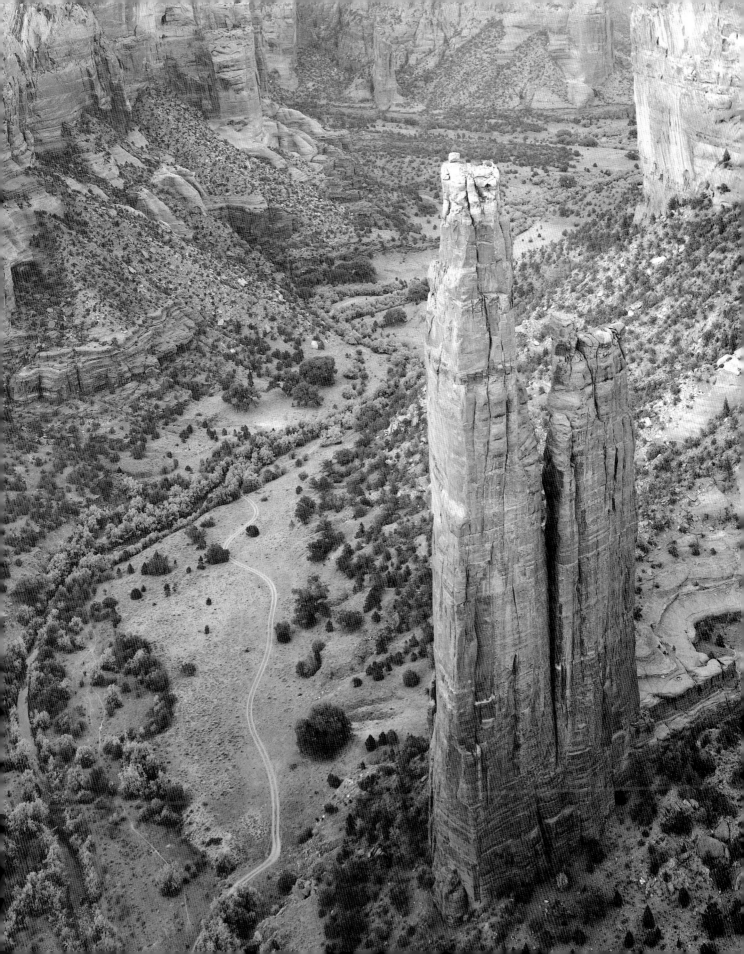

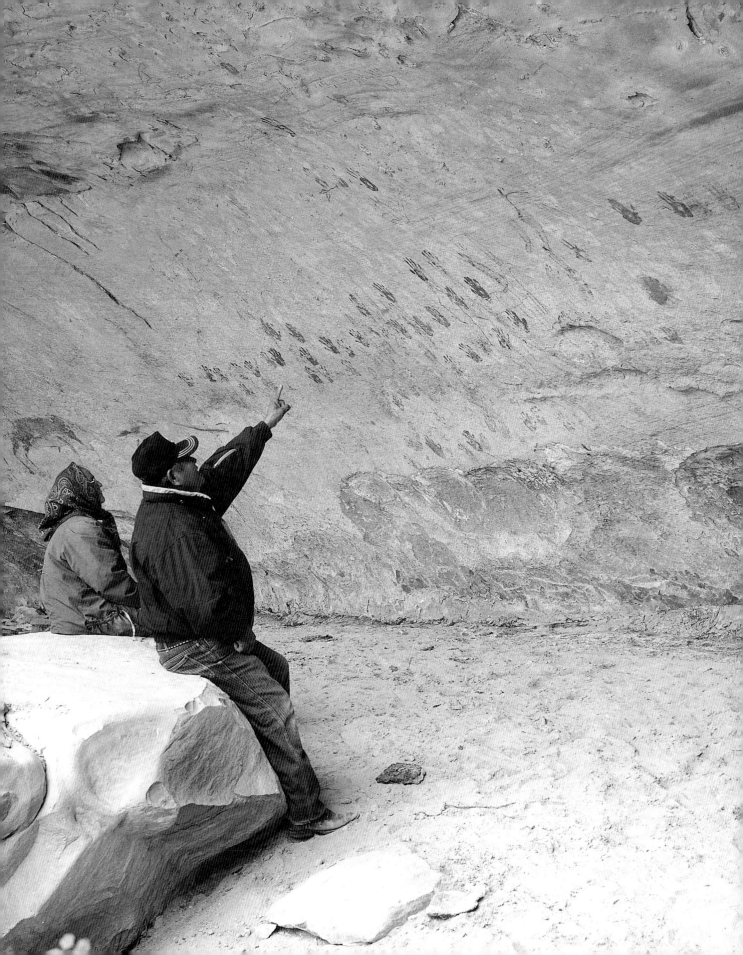

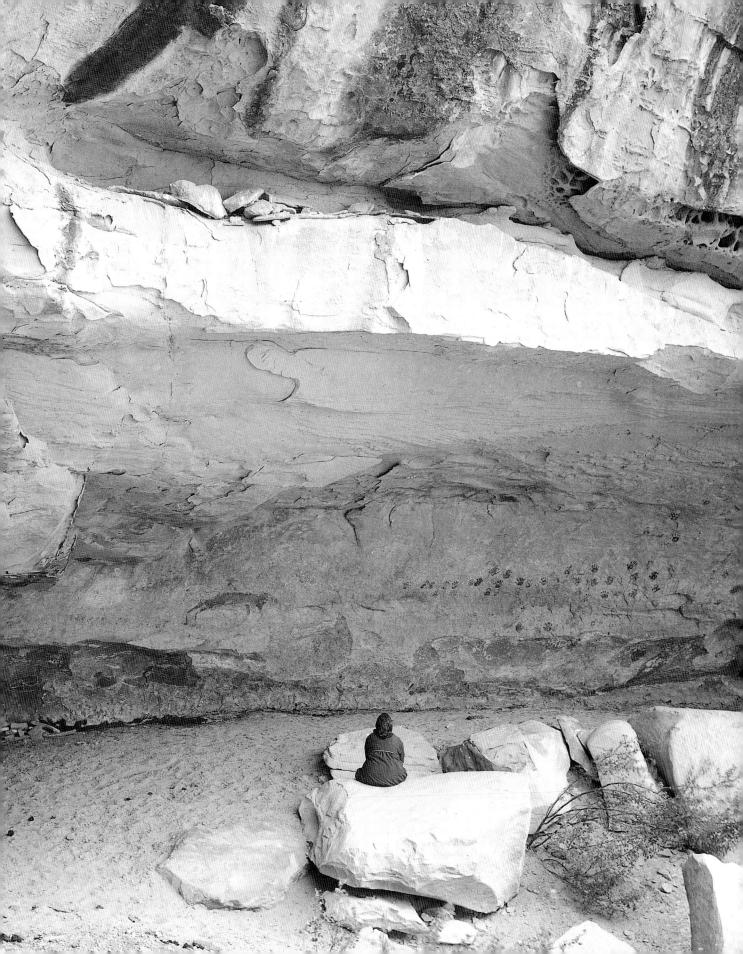

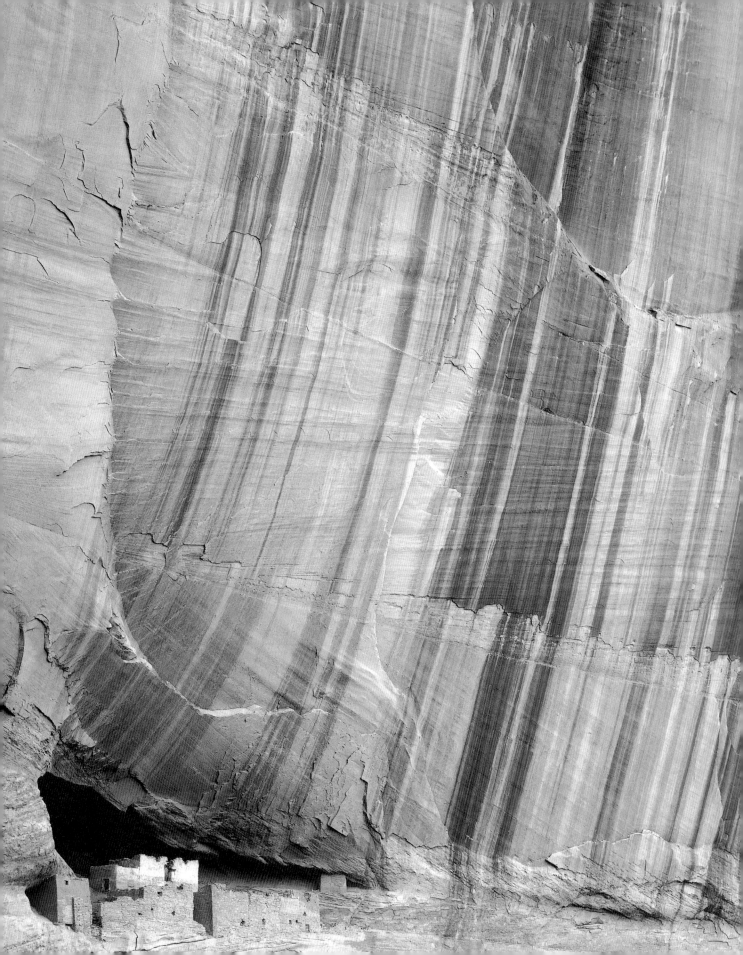

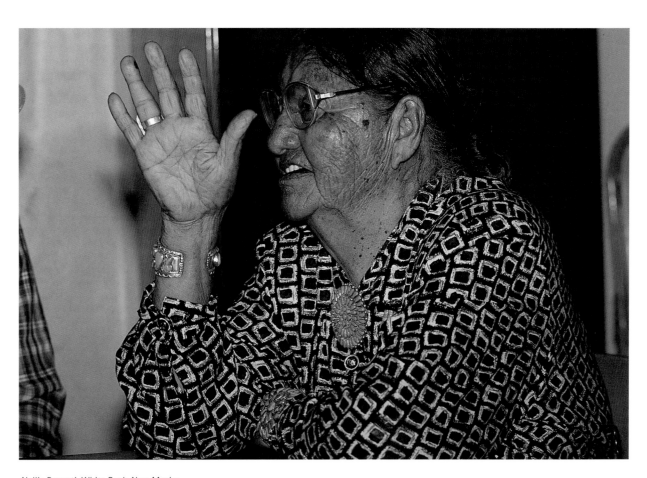

Nellie Becenti, White Rock, New Mexico

WEAVING A WORLD

WEAVING A WORLD
TEXTILES AND THE NAVAJO
WAY OF SEEING

ROSEANN SANDOVAL WILLINK
AND PAUL G. ZOLBROD
PHOTOGRAPHS BY JOHN VAVRUSKA

MUSEUM OF NEW MEXICO PRESS
SANTA FE

A portion of royalties will support the library at the Crownpoint Campus of
Navajo Community College.

The publisher gratefully acknowledges the use of material from *Diné bahané: The Navajo Creation
Story,* by Paul G. Zolbrod, (© 1984 University of New Mexico Press), and *Navajo Myths, Prayers and
Songs,* by Washington Matthews (University of California Publications in Archaeology and Ethnology,
Vol. 5[1907], 45.) Reproduction rendering of Navajo sand painting (page 87) courtesy Special
Collections, University of Arizona Library (Berard Haile Papers, AZ 132).

Project Editor: Mary Wachs
Design and Production: David Skolkin
Typeset in Rotis with Rotis San Serif Display
Museum Collections Photography: Blair Clark
Manufactured in Singapore by C.S. Graphics
Color separations by Professional Graphics, Rockford, Illinois
10 9 8 7 6 5 4 3 2 1

Library of Congress Cataloging-in-Publication Data
Willink, Roseann Sandoval.
 Weaving a world: textiles and the Navajo way of seeing / by
Roseann Sandoval Willink and Paul G. Zolbrod; with photographs by
John Vavruska.
 p. cm.
 ISBN 0-89013-307-7 (pb only)
 1. Navajo textile fabrics—Catalogs. 2. Navajo mythology–
-Catalogs. 3. Navajo philosophy—Catalogs. 4. Museum of Indian
Arts and Culture/Laboratory of Anthropology (Museum of New Mexico)-
-Catalogs. I. Zolbrod, Paul G. II. Title.
E99.N3W665 1997 96-33154
746'.089'972–dc20 CIP

Cover: Detail, plate 21
page i: Spider Rock, Canyon de Chelly, Arizona
page ii, iii: Annie and Willie James near Standing Rock, New Mexico
page iv: White House Ruin, Canyon de Chelly, Arizona

MUSEUM OF NEW MEXICO PRESS
Post Office Box 2087
Santa Fe, New Mexico 87504

CONTENTS

PREFACE

In this volume we wish to demonstrate that Navajo weaving is more than technique and craftsmanship. Rather, it is a conceptual art with much to say about the people who produce it, both individually and collectively. For help with the preparation of this work, our thanks go to a beleaguered federal agency, two fine institutions, and many generous, hardworking people. Indeed, it could not have materialized otherwise.

The National Endowment for the Humanities provided funding that enabled us to examine more than two hundred textiles in the collections of the Museum of New Mexico and to talk at length with more than sixty Navajo elders—many of them experienced weavers. We duly register our gratitude not only to the Endowment but to its sustaining public. That agency's open-minded receptivity to an unorthodox project confirms the need for government support in sharing important discoveries with wide audiences.

The supporting institutions include Allegheny College, Meadville, Pennsylvania, where Zolbrod served on the faculty for more than thirty years, and where early planning occurred; and the Museum of Indian Arts and Culture/Laboratory of Anthropology, a unit of the Museum of New Mexico, which graciously

hosted all research activities. Institutions are, however, no more effective than the people who staff them.

Marianne Jordan, Director of Foundation and Corporate Relations at Allegheny College, heads the list. People who do her kind of work go unrecognized for their invaluable help in defining research goals, clarifying objectives, and developing methodology. We extend appreciation as well to Dr. Daniel Sullivan, former president of Allegheny College, for an early enthusiasm that fueled our own and for helping to provide additional financial assistance at a crucial time. His warm backing was matched by that of former Museum of Indian Arts and Culture director Steve Becker.

Present staff members at the Laboratory of Anthropology likewise deserve grateful acknowledgment, beginning with current director Dr. Bruce Bernstein, who was instrumental in our formulating the idea that Navajo textiles are more by far than the proficient technique of adding warp to weft to produce a design and who remained available as an ongoing consultant and as a knowledgeable, creative interpreter. Curator of Collections Louise Stiver also occupies a special place among those we must thank. To our great advantage, her superb mastery of the museum's textile collection matched her assistance when needed and her patience as we learned from her the importance of handling

and caring for individual items. In addition we praise Laura Morley, laboratory and museum office manager, whose title does no full justice to the range of her helpfulness and the depth of her commitment to our success.

We hasten as well to pay tribute to other museum staff members for their assistance and committed goodwill. They include Carol Cooper, Director of Education; Laura Holt, Reference Librarian; Edmund Ladd, Curator of Ethnology; Tammy Rahr Nilsen, Curator of Living Arts; Paula Rivera, Assistant Curator of Collections; Curtis Schaafsma, Curator of Anthropology; Sarah Schlanger, Curator of Archaeology; and Jane Sinclair, Museum Educator. Together they provided a stimulating environment for inquiry and interpretation crucial to our progress. We would be badly amiss if we failed to recognize Museum of New Mexico Press Editoral Director Mary Wachs, Art Director David Skolkin, and copy editor Jenifer Blakemore for so effectively transforming our materials into a polished book. No writer is any better than those whose efforts bridge that inevitable gap. The praise we give them also goes to photographers John Vavruska and Blair Clark for seeing so clearly what the elders and the textiles combine to say.

Separately, each of us offers an acknowledgment of a more private kind as well. Roseann Willink takes pleasure in citing her

husband George for the encouragement and support that only a longtime marriage partner can provide, while Paul Zolbrod issues fond gratitude to Dr. Joanne McCloskey for strengthening all the more a close personal bond with crucial professional assistance. To her go particular thanks for initiating contact with key members of the Crownpoint, New Mexico, community who ultimately showed us how to find meaning in Navajo rugs, as well as for her guidance in developing a research procedure and for her own special kind of encouragement.

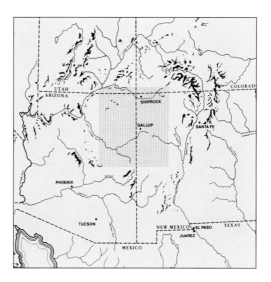

With uncanny bilingual expertise, meanwhile, Bonnie Benally helped their words and ideas find a second life in written English.

We save for last our tribute to the Navajos listed below, whose generosity anchored our piece-by-piece examination of more than two hundred textiles in an understanding not otherwise obtainable; and to Bonnie Benally, our field interpreter, who secured the conversion of supple, complex ideas to effective written English. Over a two-year period, individuals met with us in homes, chapter houses, hogans, and corrals to share knowledge that they might justifiably have kept to themselves. A number of them also came to the museum to help examine and interpret textiles collected there. It was their conscious choice to speak of things sacred and personal in an effort to preserve the essence of being Navajo for future generations. We appreciate their trust and hope to have done it justice in our representations.

Finally, we must single out among the elders a core group that became a de facto board of trustees as our enterprise progressed, guiding us and securing structure in what could otherwise easily have become a sprawling, unfocused effort. Included are June Kalleco, Sarah Johnson, Annie James, Harry and Annie Burnside, and Willie and Nellie Becenti. Learning from them as they tempered our efforts with the wisdom of their years, we discovered why the term "elder" takes on a special dimension in Navajo life difficult to summarize elsewhere.

Presiding over them and us was Loretta Benally, a powerful, prolific weaver in her time and a stalwart community leader today. It was her initiative that stirred others to work with us. She saw immediately the importance of what we hoped to accomplish for Navajos and non-Navajos alike. We owe her more than

we can ever reckon, and in an attempt at repayment we dedicate this book to her. Loretta above all speaks on behalf of all Navajo weavers wishing to give the loom a voice not otherwise heard.

Nobody named here bears the slightest responsibility for any error or inadvertent inaccuracy found in this text. Indeed, we would hasten to apologize to them first of all to underscore our earnest desire to represent the Navajos and their textiles accurately and well, and to repeat our gratitude for their help in whatever we may have accomplished.

We thank the following Navajos for sharing knowledge and information so generously: Rosita Allen, Shiprock, NM; Helen Antoine, Becenti, NM; Bernice Atcitty, Martin Lake, NM; Celia Becenti, White Rock, NM; Edna Becenti, Crownpoint, NM; Ernest Becenti, Church Rock, NM; Minnie Becenti, Crownpoint, NM; Nellie Becenti, White Rock, NM; Willie Becenti, White Rock, NM; Loretta Benally, Becenti, NM; Louise Benally, Becenti, NM; Margie Benally, Little Water, NM; Martha Benally, Becenti, NM; Timothy Benally, Red Mesa, AZ; Mary Biggs, Crownpoint, NM; Joan Blackwater, Sweetwater, AZ; John Blackwater, Sweetwater, AZ; Annie and Harry Burnside, Crownpoint, NM; Etta Chavez, White Rock, NM; Nellie Chavez, Crownpoint, NM; Juanita Costello, Little Water, NM; Rita Cowboy, Mariano Lake, NM; Caroline Hannah, Crownpoint, NM; Annie and Willie James, Standing Rock, NM; Raymond Jim, Crownpoint, NM; Joe Johnson, Standing Rock, NM; Sarah Johnson, Standing Rock, NM; Lorraine Kahn, Mariano Lake, NM; June Kalleco, Standing Rock, NM; Belle Largo, Crownpoint, NM; Emma Lee, Shiprock, NM; Alice MacCauley, Crownpoint, NM; Billy Martin, Crownpoint, NM; the late Christine Martin, Martin Lake, NM; Anna Mitchell, Little Water, NM; Blackhorse Mitchell, Shiprock, NM; Roland Mitchell, Shiprock, NM; the late Glinny Nagale, Blue Mesa, NM; Harding Nagale, Blue Mesa, NM; Ellen Neswood, Crownpoint, NM; Lillie Peterman, Red Mesa, AZ; Edna Phillips, Crownpoint, NM; Nancy Pinto, Crownpoint, NM; Richard Pinto, Crownpoint, NM; Mary Roper, Crownpoint, NM; Ruth Sanchez, Little Water, NM; Eleanor Sandoval, Pueblo Pintado, NM; Elsie Sandoval, Pueblo Pintado, NM; Leon Secatero, Canoncito, NM; Bobbie Sisco, Sanostie, NM; Matthew Succo, White Rock, NM; Nellie Succo, White Rock, NM; Marie Teasyatwho, La Plata, NM; Mabel Thompson, Little Water, NM; Harry Walters, Tsaile, AZ; Etta Yazzie, Littlewater, NM; Milfred Yazzie, La Plata, NM; Pauline Yazzie, Sweetwater, AZ; Will Yazzie, Sweetwater, AZ.

WEAVING A WORLD

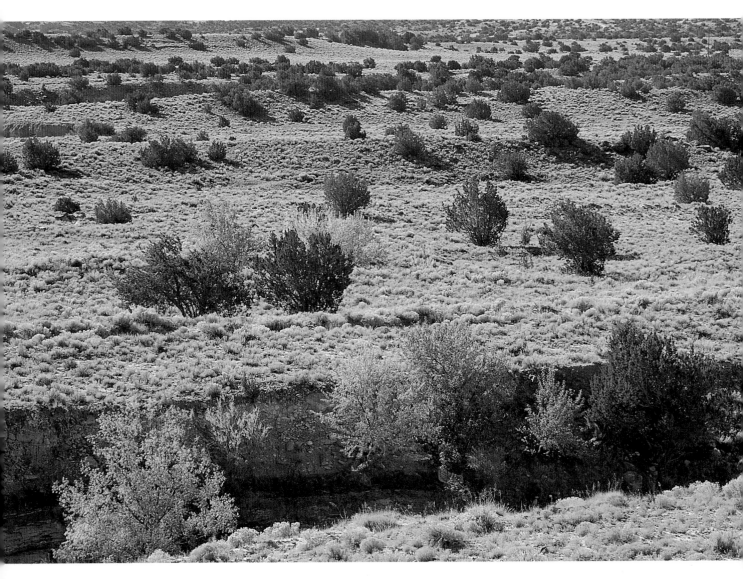

Toadlena, New Mexico

LISTEN TO THE RUGS
THE POETICS OF
NAVAJO WEAVING

PAUL G. ZOLBROD

As we bounced eastward along the narrow, rutted road that linked New Mexico Route 371 with Martin Lake just west of the Continental Divide, weaver Mary Biggs grew more talkative. A woman in her mid-sixties, she was accompanying us to where she had passed a traditional Navajo childhood. She spoke of herding sheep and learning to weave, of listening to the old winter stories, and of watching adults gather by wagon or on horseback to attend ceremonies at a place with no electricity or running water. Mostly, she told of her mother, Christine Martin, also a weaver, who had passed away nearly a year

earlier. In her nineties at the time of her death, Christine had been a mainstay among the sixty or so elders Roseann Willink and I had been interviewing to learn what rugs meant from a traditional Navajo perspective.

My first meeting with Christine—just six weeks before she passed away—impressed me deeply. It epitomized everything we had been learning by looking at old rugs and interviewing elders who had lived very traditional lives. Christine was a frail, tiny woman who hardly moved as she sat in a deep chair on the other

> "HENCEFORTH THE PEOPLE WERE TO INCREASE THEIR NUMBERS AND THEIR STRENGTH FROM WITHIN. BUT THEIR EXISTENCE AS A TRIBE WAS SECURE. THEY FLOURISH ON THE SURFACE OF THE FIFTH WORLD TO THIS VERY DAY, IT IS SAID."
>
> *DINÉ BAHANE': THE NAVAJO CREATION STORY*

side of the small room, a lap robe across her knees. But she showed great energy, talking profusely, laughing frequently, moving her eyes from me to Mary to Bonnie Benally, my interpreter, and beaming when her granddaughters came through the room with their children.

Usually it takes several visits before an elderly weaver begins to talk personally about her work, but Christine opened up before I raised even one of our routine get-acquainted questions, telling about her life as a weaver. She knew the double weave, she said, and the regular weave, the braided weave, the striped weave, and lots of patterns. She had survived by weaving; what she wove put food on the table. But weaving was not done for money alone. She could remember a time when women wove blankets for family members to wear instead of store-bought coats, just as they wore wraparound moccasins rather than shoes.

"Weaving was sacred back then," she said. She still remembered the old weaving prayers, and she knew all the old stories—the quarrel between the men and the women, the greedy gambler, the mighty giants, the Warrior Twins who defeated them. She grew up on those old tales and on the Coyote stories, too. Stories were important, especially in wintertime. Everybody would go into a special stone hogan, with no lamp, no lantern; light came only from a fire somebody would start with an old spindlelike device. When the fire began to blaze, elders would tell of the ancient times while the young people listened in wide-eyed wonder until they fell asleep. Then the grown-ups' stories would begin. Eventually those stories found their way into the rugs, even if some of the weavers were reluctant to talk about them with outsiders.

Prayers were just as important as the stories. There were prayers for everything: prayers for the weaving itself, for making battens and other tools, for seeking the right wood, for erecting a loom stand. And praying was part of the weaving process. Things came together in rugs; what was said went into the rugs as much as did the yarn. Weaving was a way of life: To live as a Navajo was to weave; to weave was to live as a Navajo.

I recalled Christine's words as we drove, eager now to see where she had lived and reared her own family. The afternoon sun was

2

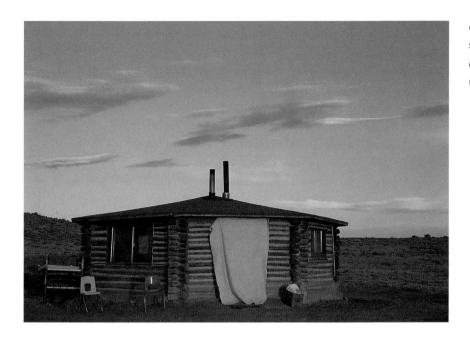

Prayers and stories about land and sky enter the rugs by way of a hogan where a weaver spends winter nights as a listening child.

losing some of its midday winter brightness, shadowing the mesa walls and the scattered piñons and junipers on this high-desert pastureland where her sons still grazed their cattle. Nobody lived here permanently now, but with Mary's reminiscences, the past came alive.

In that oven over there, Mary pointed out as we walked among the various buildings, Christine would roast corn to make kneel-down bread. In a pit just beyond the oven, she'd cook blue cornmeal mush, to be mixed with dried meat and eaten during long trips, as when Christine would walk the ten miles to Crownpoint, New Mexico, with blankets to trade. East of the house stood the hogan, where the family would gather after dark to hear the winter stories or hold ceremonies. On a level spot between the house and the storage building Christine placed her loom where it pleased her to look southward toward the mountain. And that is where Mary and her sisters became weavers, learning the songs, stories, and prayers that would make them experts.

Things Mary said about Christine reaffirmed what other weavers told us during the eighteen months we spent gathering information for this book. And their accounts match what traditional weavers have said about the vast expanse of *Dinébikéyah*, homeland to a people rich with stories. Navajo rugs are highly regarded everywhere, but the full depth of their artistry goes unrecognized when removed from their setting and from things elders say. There is more to a rug than a straight selvage, a tight weave, aniline or

Figure 1. To the practiced observer, a sense of the landscape with its richly variegated horizontal patterns appears in textiles and stonework alike (see plate 23).

vegetal dyes, or an even pattern. An entire culture might be woven into a single textile: its mythic and historical associations, its ceremonial practices, its need for balance and order, its sense of place. The earth and the sky, the light of day and the dark of night, the mesas and the canyons together with all they represent have found their way into warp and weft as securely as has the yarn.

With our visit ended, we started back that late afternoon the eleven unpaved miles to the Crownpoint highway. Before long, a coyote ambled into view over a nearby northern ridge, followed by another, then a third and a fourth, all skulking along in their seemingly hapless coyotelike way. With darkness coming, they were gathering to attack a calf that had strayed too far from its mother, or so Bonnie thought and Mary agreed. Both advised that we stop and chase them off or surely the calf would be eaten. We pulled over, got out of the vehicle, and made a clamor by banging on the fenders, whistling, shouting, and throwing stones until one by one all four would-be predators turned tail back across the ridge and out of sight.

That final episode rounded out the whole afternoon. Missing so far had been the ubiquitous trickster *Maʼii*, or Coyote, agent of disorder who arouses the need to keep things in their place at the loom, as well as in the wider scheme of things. The Navajo story of this

world's creation tells how Coyote objects to letting people live forever. Everlasting life, he argues, would be deadening. No cornstalk or blade of grass would have to struggle to stay alive. No humans would strive to produce food and keep warm. One season would not follow the next. With perfect immortality, nothing would change. There must be imperfection if there is to be a dynamic, living world, in rugs as well as in a dynamic universe.

During an eighteen-month period we met with more than fifty elders, most from the easternmost part of Navajo country in the Crownpoint region. We asked them to talk about rugs in the context of their own lives and their culture. With only one exception, their ages ranged from the early forties to the nineties, although most were over sixty. As the eldest, Christine Martin became a figurehead for the group as a whole. This sampling, hardly a Reservation-wide consensus, was nonetheless enough to indicate that what Navajos themselves say about weaving adds considerably to what non-Navajo scholars, dealers, and collectors customarily discern and communicate about the textiles.

The majority were weavers who had learned the traditional way from grandmothers and mothers, first by herding sheep and carding and spinning wool, then by working at the loom. We interviewed several medicine

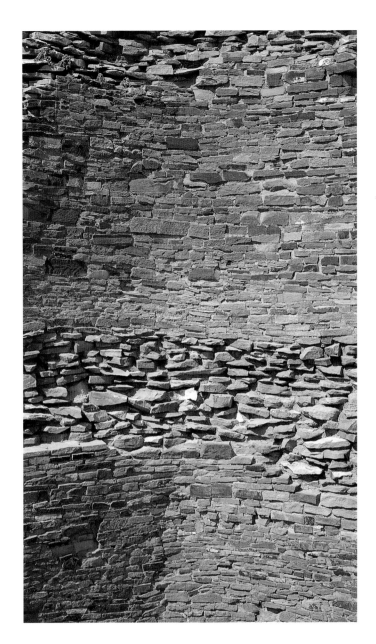

men and a number of spouses as well and discovered the extent and importance of male participation. In most cases we met with people singly or in small groups, visiting them over and over, sometimes in the sheep corral or the pasture, sometimes in the family hogan, sometimes as they wove. And we invited groups of them to the museum as we examined more than two hundred textiles in the Laboratory of Anthropology's collection, often scrutinizing a single item for hours in light of stories and ceremonies that are fundamental to a Navajo perspective.

The elders did not always agree in their interpretations; this did not surprise us. Indeed, we expected disagreement. Some who have written about Navajo weaving cite it as a reason for dismissing efforts to find meaning in the rugs. Others draw different conclusions. Scholar Susan Gillespie writes in *The Aztec Kings: The Construction of Rulership in Mexican History* (University of Arizona Press, 1989) that the inconsistencies in Aztec histori-

cal accounts recovered from oral tradition tell us as much as do the consistencies. In my own efforts to assemble a written English version of the Navajo Creation story (*Diné bahane': The Navajo Creation Story*, University of New Mexico Press, 1984), I found much the same thing. While responses to a particular textile may vary, it is obvious that Navajo weavers identify each piece with a shared identity, just as Anglo-Europeans bring a common heritage to Western literature and art while sometimes disagreeing over interpretative details. A different group from a different part of the Navajo Reservation may well compile a different set of interpretations, but these, too, would be Navajo, ultimately reducible to a shared tradition distinct from that of the Western European heritage.

Accordingly, we have assembled these textiles and photographs to encourage listening with the eye, as it were, to understand how elderly Navajos might view and respond to the *diyogí* after a lifetime of learning stories and songs while young and reciting them over and over while growing older. In keeping with five stages of creation that many traditional Navajos recognize in telling how the world came to be, we have arranged the textiles beginning on page 35 into five groups: The Mythic Memory, The Collective Memory, Ceremonial Practice, Harmony and

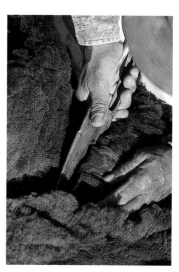

Not just a single product or an end result, weaving is an ongoing cyclical activity that includes caring for sheep, processing wool, and working the loom. In one way or another, an entire family participates.

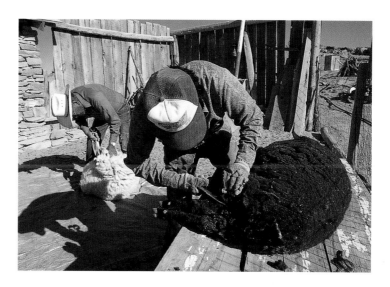

Disharmony, and A World in Motion. Many of the pieces consigned to one group could easily fit into another; multiple meanings apply everywhere in the Navajo worldview. But a worldview it remains, fascinating and legitimate in its own right. The categories offer a framework for "hearing" what Navajo rugs might have to say.

To be sure, there is remarkable workmanship here; it speaks for itself in art's transcendent way. And there is poetry, too, in these blankets and rugs—locked in absolute silence until the elders give it a voice, however individually. Art's meaning often resides in a story that dwells somewhere deep in the object. Navajo textiles must be functional to be beautiful. They must create warmth and comfort, offer protection from dangers within and without, preserve individual and collective identity, and maintain stability while accepting change. That merger of beauty and function becomes understood when color, texture, and design are "heard" and the stories and songs "seen."

Shil' hózhǫ́, goes the refrain of many a Navajo prayer that accompanies a weaver's work: "with me there is beauty." *Shįį' hózhǫ́*, it continues, "in me there is beauty"; *shits' ą́ą́ dóó hózhǫ́*, "from me beauty radiates." This beauty incorporates form, function, harmony between components, and recognized meaning. It finds expression not in one art alone but in speech and prayer combined with song and dance, story and ceremony, and in the way individuals live out their lives as they make and do, see and hear, offer and accept, create and consume.

THE STORIES

Navajo textiles belong to the weaver and her culture. She owns a different past and hence acquires a different way of seeing and knowing than do non-Navajos. The elders we met grew up in a world unlike anything familiar to mainstream America. Few listened to the radio, talked on the telephone, visited a library, saw a movie, or traveled far from home. As children they tended sheep, heard tales told by their elders, and learned to sing Navajo songs and dance the Navajo way. Literally, they lived closer to the earth and sky in that high-desert country of the Four Corners region. Living on the Reservation meant observing the sun and the stars according to stories repeated again and again as a living tradition. It also meant seeing far fewer things than can be seen in today's image-laden, wired reality, but seeing them repeatedly in light and shadow, day after day.

A fundamental reality is textured into a Navajo rug that admiring buyers and dealers have not yet fully understood. Even in the face of trader influence and an encroaching modern world, ancient Navajo thought finds

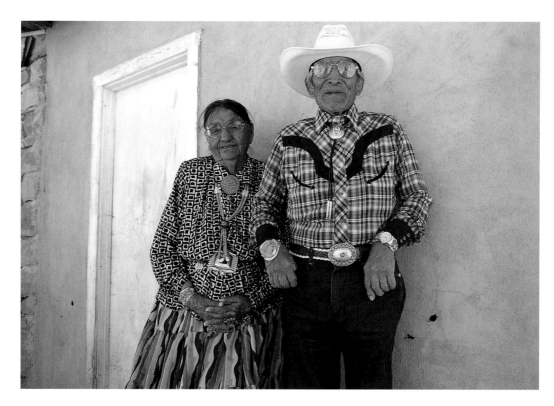

Willie and Nellie Becenti, White Rock, New Mexico

(below)
Loretta Benally, Becenti, New Mexico

its way into the loom. The textiles bear a tradition that survives through what weavers know and preserve. They are the stuff of history and poetry, carefully structured and powerfully expressive of a distinct sense of past, present, and even future.

Much as any culture's books and artifacts tell of the past, Navajo rugs record earlier times; and like poetry, they speak metaphorically and symbolically, sometimes by way of an overall design issuing from an established family pattern, sometimes through changes in coloration worked into the yarn. Our most important discovery was learning about another way in which metaphor and symbolism

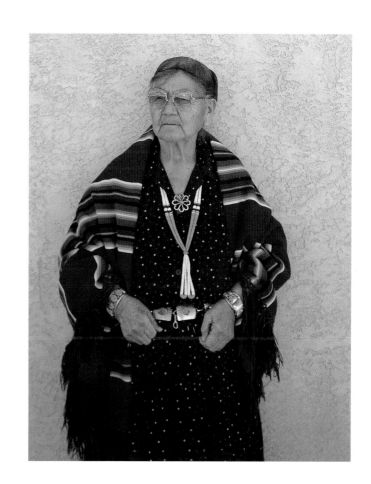

Annie and Willie James, Standing Rock, New Mexico

were articulated. The weavers had deliberately woven into the weft barely visible particles—bits of feathers, animal tissue, plant matter, various fabricated materials—bearing a significant symbolic role and serving a tangible purpose. In these minute, symbolically charged particles the poetry of some rugs is augmented and amplified.

The incorporation of such items indicates a deliberate purposefulness on the part of a weaver, an aspect of these rugs generally not acknowledged in conventional studies and commentaries on Navajo weaving. Many of the items are related to stories or the ceremonial procedures that grow out of them. Most of the two hundred rugs we examined contained at least one sliver of quill or down, reminding us that birds are major players in the Navajo storytelling tradition. *Ţązhii*, the Turkey, recovers seeds from a flood so that those fleeing it may plant crops where they take refuge. *Né'éshjaa*, the Owl, helps men and women reconcile after a bitter quarrel. *Atsá*, the Eagle, rescues heroes from ledges and peaks. Because their feathers have the ability to move through the air like speech

Texture changes, shifts in coloration, and minute particles woven into the rugs work metaphorically and symbolically. Top row: pollen knots; middle (l to r): feather, sinew; bottom: subtle but intentional color shift.

Figure 2. Repetition can be as much a feature in a weaver's design as it is in Navajo stories and prayers. Manta dated 1899.

and pollen, birds are messengers to the Holy People, the *Haasch'éé diné'é,* and their feathers can impart special power to rugs. A great deal of traditional knowledge is thus woven into a rug and invites consideration of what a weaver wishes to express.

Navajo rugs invoke a mythic time of creation and arrival unlike anything recorded in Genesis. They testify to a bitter history of exile and suffering with the coming of outsiders from the East. They bear witness to a ceremonial reality that keeps the Navajo people in touch with their own powerful deities. As finely ordered creations, they demonstrate the struggle of maintaining order and harmony in a world where disorder is an ever-present danger. At the same time, they reflect cycles of movement and change in a dynamic world.

I. THE MYTHIC MEMORY: EARTH, SKY, AND THE HOLY PEOPLE

Whether subtly or directly, with the force of conscious intent or the undercurrent of collective awareness, the rugs appeal to an ancient voice that tells of primordial creation. A classic Navajo story repeats a special verb in a special tense, *ájíní,* which literally means "one has been saying that for a long time." *Ajíní* and all that it means is as easily seen in a saddle blanket or manta as it is understood during a story's recitation.

Previously overlooked stories describe exciting events and possess the power to arouse deep feelings. They tell how men and women once bitterly disagreed; how sons disappear while hunting, daughters are lured away, the monsters ravish the earth, the Warrior Twins make their way into the sky to ask their father *Jóhonaa'éí,* the Sun, for his help in vanquishing the monsters. Such storytelling is typically diminished by the careless use of the terms "myth" or "legend," especially since it comes out of an oral tradition. With their steady suspense and the panoply of wis-

dom and insight, however, the stories deserve ranking with the world's great literary classics.

When assembled as a single long narrative, the stories chart the upward progress of an innermost world's original insectlike inhabitants, the *nilch'i diné'é,* as they learn how to forge a community. Little by little these denizens develop biologically, socially, ethically, and spiritually, helped and prodded along by the supernaturally powerful Holy People. As the insectlike inhabitants evolve, they finally assume human shape, then help give the world and the space around it its present features. First they establish earthly boundaries by fixing mountains in each of the four cardinal directions plus three more to mark the center of their world. They place the sun and the moon in the sky and fill it with stars that glow each night for a future race of *ni'hookáá diné'é,* or five-fingered earth surface people. Their progress is disrupted, though, by Coyote's tricksterism and then by the monstrous giants, who must be overcome before the world can be made safe for a community of organized clans. Intricate though it may be, the story maintains the central theme of *hózhǫ,* a Navajo word at best approximated in English by combining words such as "order," "beauty," "balance," and "harmony."

What is striking when looking at the rugs is how readily that theme appears once a viewer understands it. At its heart lies an

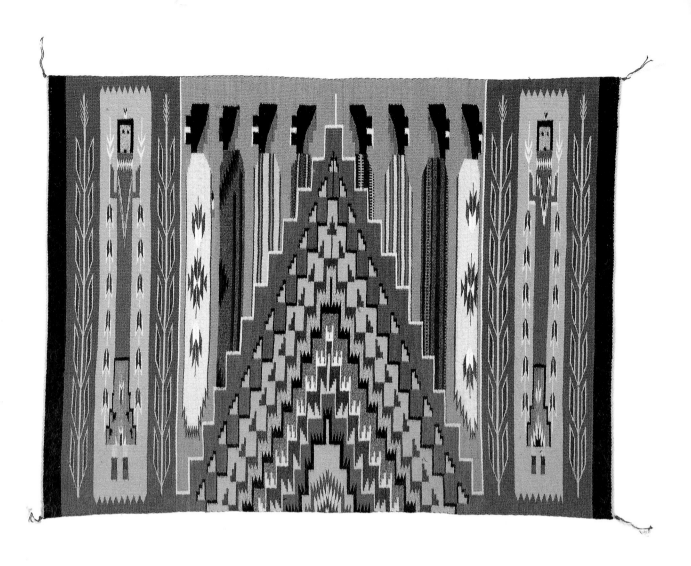

Figure 3. Deeply embedded in Navajo mythic thought, gender finds its way into the work of today's weavers, as this piece by Alice Begay from Burnham, New Mexico, shows. The subtle difference between each female figure, added to the contrast between them and the ye'ii, reaffirms an equity between male and female that both must strugle to maintain. Private collection of Joanne McCloskey.

ongoing interplay between men and women, which develops throughout the entire narrative. The original inhabitants are forced out of the first world because males and females, having committed adultery, fail to get along. Repeated again and again, the sexual trans-gressions result in an intense misunderstanding that corrects itself slowly and painfully as the story unfolds—but not before leaving a legacy of waste and destruction.

Sometimes a woven pattern will display elements of such a plot. Others may remind some elders of the way harmony slowly develops as men and women gradually learn to live together. Similarly, the traditional weaver must coordinate the loom and the tools she uses, the wool she processes and weaves into it, and even the songs and stories she has learned. As many elders say, making a

Figure 4. Once known, a standard narrative can give a seemingly simple diyogi *an added dimension of meaning. As one youngster recognized, this blanket, dated 1890–1910, with its five zones serves as a reference to the emergence through four lower worlds to a fifth. Also notice how it suggests the progress of a single day cycling from pre-morning darkness to the darkness that follows dusk.*

rug reenacts the creation of earth and sky. The process begins with raw wool and takes shape gradually as carding gives way to cleaning, spinning, and dying. Once given shape and color, the yarn can then be woven into a coherent pattern until it is a finished rug with a distinctive, one-of-a-kind quality equivalent to the world that *Ałtsé hastiin,* the First Man, and *Ałtsé asdzą́ą́,* the First Woman, craft with help from the Holy People, among whom the *Nı́łch'i diné'é,* the Air Spirit People, take their proper place (see plate 1).

Young weavers grasp that principle almost instinctively. During a routine visit we presented a seemingly undistinguished saddle blanket to fourteen-year-old Katrina Yazzie, a middle-school student whose grandmother is teaching her the traditional way of weaving. The blanket interested us because of its varied shading and the way the weave shifted. When we asked Katrina why she supposed the weaver made it that way, her answer came quickly: "Because it shows the progress of the people as they made their way up to this world," she said, "moving from the darkness below into the everyday sunlight."

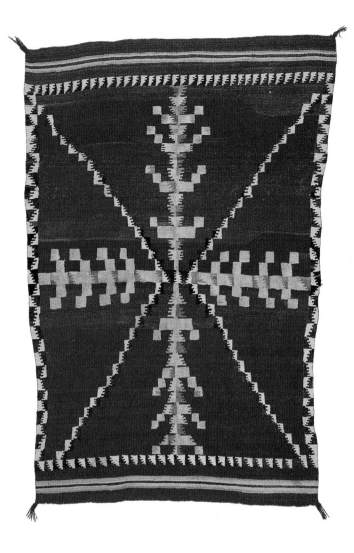

If Navajo rugs embody mythic time, they record historical time as well. Who the Navajos are today depends not only on the enduring voices that preserve the ancient stories but on more recent ones born of living memory, voices that add to the poetics of weaving. While scholars disagree on the timeline for the arrival of the Navajo people in the Southwest, as well as on their route of migration, the historical record clearly indicates that by the mid-1600s they had settled in the Four Corners area and were living as seminomadic pastoralists. The newcomers drew ideas and techniques from neighboring cultures. From the Rio Grande Pueblos, Navajos learned to plant corn and to weave on an upright loom. From them they incorporated elements of Tewa cosmology into their worldview. From the Spaniards, who had introduced both horses and sheep to the region, they learned horsemanship and herding skills. But more than the sum of their borrowings, Navajo weavers distilled an identity of their own making. There is much in their stories, ceremonies, and language that suggests that something purely indigenous informs what they weave.

The Navajo settled into a vast area of northeastern Arizona and northwestern New Mexico long abandoned by the early Pueblo

Figure 5. As Navajos perfected their weaving, it developed as an expressive art in keeping with stories the people told and ceremonies they staged in a land where their culture took root. No matter how abstract a pattern may seem, it derives from what weavers see over time.

people. It was an area of little interest either to the Spanish settlers or to Anglo-Americans who flowed into the region with the opening of the Santa Fe Trail in 1821, and in increasing numbers after the Mexican War broke out and New Mexico subsequently became a United States territory in 1848. Uniting steadily as a people, the Navajo flourished as raiders and traders in this region of the northern Southwest they came to consider their homeland.

In 1864, the United States Army of the West escalated the campaign to pacify the Navajos and neighboring Apaches by rounding up some seven thousand Navajos and four hundred Mescaleros for internment at Bosque Redondo, a military reservation near Fort Sumner in eastern New Mexico. During their four years of incarceration, dramatic changes were visited on the Navajos and their culture. Lost were their herds of churro sheep and access to the wool they used in making textiles. Instead they were reduced to using recycled yarns or military-issue commercial yarns and cloth. While commercial dyes and yarns, as well as exposure to Spanish Rio Grande textiles, added variety to their product, the use of manufactured materials cheapened it for a widening market. Manufactured clothing supplied by the government undermined traditional weaving practices among the Navajo during their captivity.

In 1866, the Navajos were released. Many died in the three hundred-mile return walk, and those who survived found their homes, pastures, and flocks destroyed. The tragedy of Bosque Redondo, and the legacy of the Long Walk that removed Navajos from their land and their herds, remains with the people today like scar tissue, prominently etched in the elders' memories, for they remember having heard about it as youngsters gathered in fire-lit hogans. Many vividly tell of how women contrived to obtain woolen underwear to unravel; how they foraged for discarded remnants of wool for something to weave with; how they struggled as captives to find paraphernalia for ceremonies; how following their release they made their way back home—barefoot, hungry by day and cold by night, many dying by the wayside. The well-preserved details of second- and thirdhand accounts indicate that younger generations suffered vicariously by hearing what their elders wanted them to know.

Fort Sumner motifs arouse a pensiveness for Navajo people today that is comparable to what the European Holocaust evokes in survivors. We found that the merriest gathering would fall into silent recollection if mention was made of the Long Walk and the years of captivity. We showed the weavers a textile (plate 6) that either was produced at Fort Sumner or woven soon after the Navajos'

release and asked for comments. This item elicited more commentary than any other, and it evoked a perceptible reverence. In the rug were seen elements variously identified as tears, shafts of sunlight making their way through the ensnaring darkness, prayers recited by the captives, and images of the ever-sacred and symbolic pollen. Its details inspired a wide range of sometimes conflicting responses. All who saw it, including those who disagreed in interpreting certain details, shared a heritage that outsiders without knowledge of the Navajo past would not recognize.

Elders associated several other textiles with Fort Sumner as well. In one of them, Christine Martin confirmed something we became more accustomed to hearing as we continued examining older museum pieces. Seeing a photograph of the textile in plate 8, she saw the diagonal cross as a signifier of the Long Walk and of the Warrior Twins' perilous sky journey. Others were reluctant to say so outright since stories about the Twins are among the most sacred. Certain medicine men could recite them only during winter storytelling season, after the young children were thought to be asleep. During one museum visit, a group of Navajos identified the step-like design in plate 5 as a visual reference to the trials the Twins endured in making their way to the Sun, much the way the stairlike motif does in plate 8. And while Minnie

Bicenti, a woman in her eighties, could say nothing about the piece directly during a springtime visit to her home, she identified the barbs as people walking—perhaps making their arduous way to and then back home from Bosque Redondo. The elders often indirectly alluded to a connection between the Twins and the Long Walk, often with an oblique reference to or an implicit suggestion on the nature of portentous journeys.

Cross-referencing the Long Walk with the journey of the Warrior Twins illustrates how a textile can make references on two or more levels, the way literary allegory does. In a culture that treats the past as something virtually alive, the Long Walk merges with later events in the Navajos' historical record, such as the disruptive coming of the railroad and the sheep reduction mandated during the Great Depression. History repeats itself with the will of a deity visiting and revisiting. In addition to being associative, Navajo thought is also synthetic, not analytic; accumulative rather than reductive. Things are better understood when brought together for consideration, not by being reduced to smaller and smaller components that are observed separately. Hence, a mythic event such as the episode of the Twins merges with the Bosque Redondo ordeal, the incursion of the steam locomotive, and the slaughter of sheep in the name of soil conservation. For traditional Navajos, the past is

recycled in the present to secure harmony in the future.

A case in point occurred during one visit by a group of six weavers, four of whom knew us quite well and were familiar with ou investigation and its purpose. The two new-comers among them became uneasy as we examined a ceremonial piece in detail, and one voiced the objection that too much information was being revealed to outsiders. That prompted the others to defend our project by explaining how this was an effort to preserve knowledge otherwise lost. "Today's young people do not know about the Navajo past," elder Harry Burnside said, "which puts the Navajo future at risk." He explained that if they can preserve this information for them, perhaps they can create another cultural revival like the one achieved after the Long Walk. To Burnside, renewing interest in the old way of listening to rugs was yet one more successful return from the venture into the sky, an added recovery from the Bosque Redondo ordeal. It stands to reason as well that weaving a rug could also re-create those arduous journeys out and back—for the weaver as she stacks the weft cords through the warp and for the informed elder as she or he beholds and remembers. To weave in the present is to summon the past.

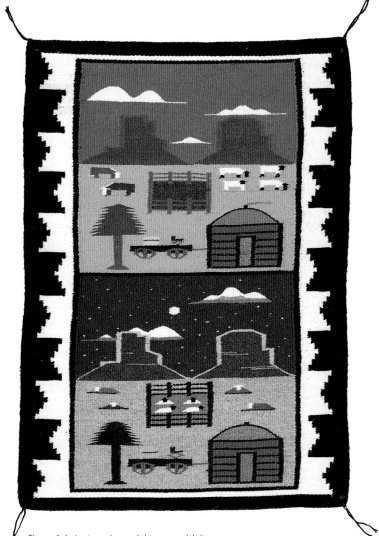

Figure 6. In juxtaposing a night scene with its daytime counterpart, this weaver illustrates a process of association that matches what is different with what is the same within time's repetitive cycles. The mythic past and historical past offer the same cyclical repetition. Private collection of Joanne McCloskey

III. CEREMONIAL PRACTICE: SUMMONING THE HOLY PEOPLE

Ceremonies, too, draw the past into the present by replaying a mythic triumph over illness and disaster. They are invocations to certain Holy People who once helped to preserve lost harmony. Through supplication, song, and sacred offerings, those deities could be asked to heal or protect humans in times of illness, conflict, or even emotional crisis. The summons is ordinarily completed with the preparation of a sand painting depicting those deities whose help is wanted.

A number of the elders have confirmed that rugs as well as sand paintings could be used in the practice of appealing to the ancient past to reckon with the troubled present. A regular ceremony requires detailed preparation and time to make the sand painting; in an emergency, however, a ready-made rug can provide an effigy at once. If no such textile is available, a simple figurine could be quickly fashioned. With a strand of fiber attached, the figurine would become endowed with extra power. That piece of string or yarn could then be woven into a rug or a blanket as a way of transmitting the protection sought with the hurried production of the figurine.

Scholarly elder Leon Secatero expressed the belief that many rugs woven between 1880 and 1920 were made to be used in ceremonies for healing influenza, then rampant.

A small sliver of nonwool fabric woven through the weft can indicate the transfer of protection from a ceremony to a diyogi *It is a common feature in older textiles and indicates that a piece was woven not commercially but for home use.*

Because of the rate of occurrence, making elaborate sand paintings was not always possible or economically feasible. Willie and Nellie Becenti explained that an extended family would keep a ceremonial textile on hand for any member in the event of an accident or sudden illness.

Just as a sand painting is destroyed once the invoked deity is no longer wanted, a ceremonial rug is put away once its power has been realized, especially when elements in the patterns bear a close resemblance to those in sand paintings. When she saw the serpent fig-

ures in a photograph of plate 11, for example, Nellie Becenti refused to call them by name. While we were gathered around their kitchen table discussing the rug, Nellie's daughter and son-in-law came in with their young children, whereupon she and her husband Willie asked to have the picture placed out of sight. Seeing the textile in plate 12 during a museum visit, a group of six backed away and were reluctant to talk about it. Since the rug was woven for protection against an enemy, its power was inappropriate in this setting, especially now that spring was at hand and storytelling season was over.

In a ceremony, the principal participant or group becomes the protagonist of the narrative, acquiring knowledge and strength from deities who help him or her survive an ordeal. That power restores the well-being lost during some terrible crisis or it can fortify the patient in anticipation of some threat to the *hózhǫ́*, or balance and harmony, each individual needs internally. Often, due to a willful act or error in judgment, the main character is driven away or takes flight from home and family, losing his needed inner balance and suffering to the point of death or physical destruction. Perhaps the protagonist is wantonly victimized or abandoned. At this juncture, the Holy People intervene and rescue the patient through song and ritual action, which then are taught to the patient.

The plots are comparable to other cultures' stories in which heroes and heroines recover from their own youthful errors to become wise adults. The foolhardy twins and the hapless gambler in the Male Shootingway and Plumeway ceremonies respectively face essentially the same hazards and require much the same kind of tutelary help to recover from their own misdeeds or from the malevolence of other individuals or forces.

In much the same way that the Roman Catholic Mass reenacts the Passion, Navajo songs and related ceremonial activities invoke a story. With their special language, the singing and chanting re-create the adventure or key episodes, usually continuing through much or all of the night. At intervals during the proceedings, the patient sits inside the sand painting or on the textile in order to absorb the needed power. This is done under the watchful supervision of a medicine man; often looking on are family members and well-wishers who desire the patient's restored or continued well-being and who have in

"ONCE I BEGAN SINGING WITH THE OTHERS IN THAT FIRE-LIT HOGAN, I REALIZED THAT I COULD ENTER INTO THE SPIRIT OF THE CEREMONY. . . . AS THE NIGHT WORE ON AND PROGRESSED TOWARD MORNING, I FOUND MYSELF TOTALLY ABSORBED IN THE GATHERING, RECOGNIZING MORE AND MORE THE ARCHAIC LANGUAGE USED TO ADDRESS THE HOLY PEOPLE SO THAT I COULD UNDERSTAND MUCH OF WHAT WE WERE SAYING TO THEM. FULLY DRAWN INTO THE PROCEEDINGS, I BECAME ONE OF THEM AS THEY SUMMONED THE DAWN WHILE EXPRESSING ITS FULL MEANING TOGETHER WITH THAT OF THE SUN AND THE MOON, THE WIND AND THE MOUNTAINS, THE CORN AND THE SHEEP—ALL LINKED IN A MEANINGFUL, HARMONIOUS COSMOS. I WAS ONE OF THEM HELPING TO ACCOMPLISH WHAT THEY HAD GATHERED TO DO."
—Paul G. Zolbrod, journal entry, June 25, 1995

many cases helped with preparations. Each gathering requires a different procedure, and serves a particular purpose since each has its own story with its own application. Each medicine man approaches a ceremony in his or her own way depending on the occasion. But it is a special time and becomes a chief event for sacred activity among traditional Navajos.

A ceremony calls for the generosity, goodwill, and wisdom that dwell at the heart of classical Navajo thought. The patient's family provides food, gifts, and hospitality. Friends, neighbors, and relatives gather and offer help. The medicine man imparts knowledge and advice patiently gathered over years of study and learning, reminding patient and onlookers alike of the abiding strength that a shared past makes available. Indeed, well-being restored to patient and participants can

be shared into old age and passed on to future generations.

Traditional elders often will match a rug with a particular ceremony. One group visiting the museum's collection associated the textile shown at right with the *Kinaaldá,* or Girl's Puberty ceremony. Plate 15 was related to the Male Shootingway ceremony. Such references evoke tales in which *Asdzą́ą́ nádleehé,* Changing Woman, departs to make her home with the Sun, and Holy Man is swept by lightning into the sky domain of *'Ii'ni' dine'é,* the Thunder People, because he used sacred arrow feathers without permission. As traditionalists, members of this group internalize the harmony implicit in the partnership between Mother Earth and Father Sky and the bodily harmony that comes with long life and happiness, attained through an individual's good health in both body and mind.

The rugs thus bring to life the stories and the songs, evoking memories of intense night-long gatherings. Attending the gatherings meant visiting with far-flung neighbors otherwise seldom seen; sharing a meal of ribs and mutton stew before entering the ceremonial hogan; expressing reverence for the male and female spirits of long life and happiness who conjoin in each individual to assure a meaningful existence; greeting the sun's first light as a night of singing draws to a close. The

songs resemble what a weaver may sing at
the loom or what her husband might recite
while gathering wood for the tools she uses or
for the loom's upright posts.

When a certain kind of rug is being
made, the collective spirit of the weaver and
her family members converges with the words
of a ceremony and the power it summons
from a shared past to regain a hard-won order
that is for the five-fingered earth surface

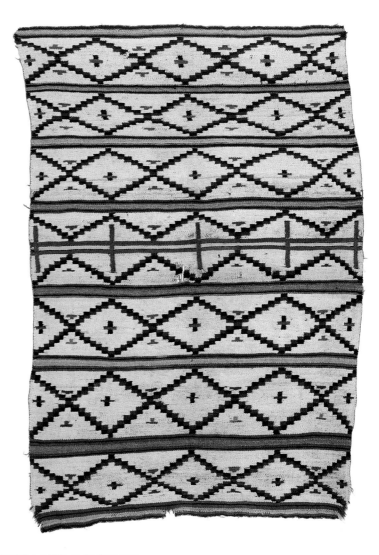

Figure 7. Identified as a diyogi *woven for use in a kinaaldá,
or female puberty ceremony, the worn spot in the middle
shows where the girl sat while her hair was tied.*

*(below) Ceremonies usually begin after darkness falls, last
through the night, end at sunrise, and take place in a family
hogan.*

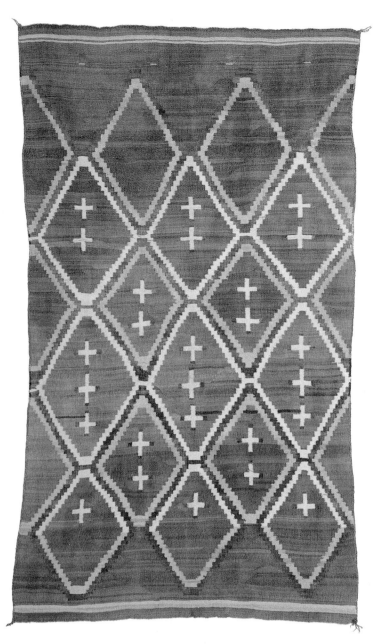

Figure 8. Nature produces harmonious patterns but not symmetrical ones, as in this 1890 blanket. In weaving what they see, traditional weavers likewise avoid symmetry.

people to recover when lost and to safeguard while it prevails. "There were always a lot of ceremonies being performed," said Loretta Benally, now in her seventies, telling of her younger years. "When the world was very holy, every neighbor had some kind of ceremony in preparation or in practice." Weavers would attend them all, hearing the songs again and again. "The prayers and the chants would stay with you and come back to you as you'd weave."

IV. HARMONY AND DISHARMONY: KEEPING THE WORLD IN BALANCE

It is *hózhǫ́* above all that must be preserved, whether lost temporarily through the rash misjudgment of errant men and women in the stories or permanently threatened by Coyote's self-seeking ways. Virtually every textile featured here reiterates that theme, often through the subtext of a related story as well as in its very design.

Hózhǫ́ is not absolute symmetry, though, and to look for such "perfection" misses the point. Perfect symmetry is to the Navajo vision of the world what a well-managed suburban lawn is to nature. We may long for such ordered tidiness but we do not find it on earth, with its brambles and weeds, or in the sky, with its sunspots and meteor showers. Symmetry is something traders have demanded

and buyers often seek. Today's weavers may produce it, but symmetry's static repetitiveness does not reflect the dynamics of order, beauty, balance, and harmony—*hózhǫ́*—in a cosmos constantly in motion. A careful look at a contemporary trading post rug will sometimes reveal a slight variation along one edge or in a corner, all too easily passed off as a mistake in a piece of otherwise absolute precision. In many cases, that "flaw" identifies the weaver as an elder, steeped in tradition, who wants to sell her work in today's market while averting the deadening symmetry Coyote warns against.

Minnie and Edna Becenti are both in their eighties and steeped in traditional knowledge. Together they explained how the weavers could work around the traders' demands and specifications. Yes, they agreed, the trader would tell them what to weave, what he wanted. He might give them a strip of wood to show them how long a rug should be, then another one to show them how wide. Or he would give them a picture. "We did what the trader said to do," Minnie said, sharing giggles with Edna. "But we also managed to do what we wanted. We managed somehow to retain a little bit of our ways, our own ideas. We found a way to stay true to our own patterns." With a chuckle Edna added that a weaver often found a way to put a

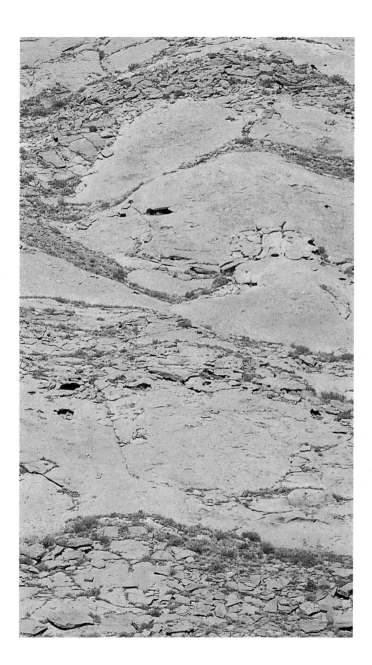

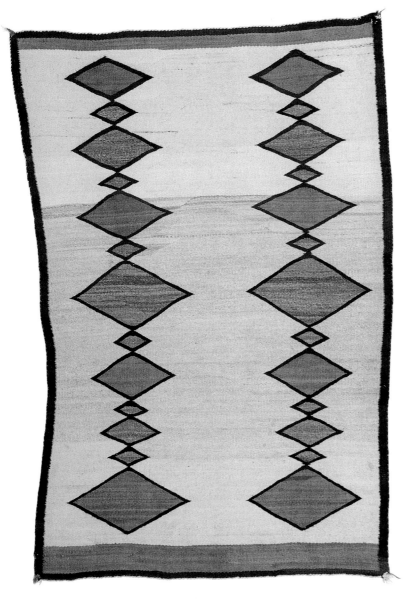

Figure 9. Sometimes dawn appears along the bottom edge with a thin white line such as those seen in this 1905–25 rug. A weaver may also indicate day's first light with a broader strip of white or some lighter shade in contrast with its topmost counterpart.

little bit of herself into a rug, unnoticed by even the most demanding trader.

Harry Walters, director of the Navajo Museum at Navajo Community College in Tsaile, Arizona, had this to say during a memorable conversation in the fall of 1995: "Rugs cannot be perfectly symmetrical anyhow, because Nature is not perfect, even thought the illusion of symmetry prevails." Commentators tend to select only symmetrical items to display, however, or they limit their illustrations to expertly done items showing no signs of wear. In doing so, they often overlook functional pieces that have much to say; thus unwittingly do "experts" promote a misleading norm. Of the more than two hundred specimens we examined, many were apparently woven for a purpose. Hardly any at all were perfectly symmetrical, although they showed remarkable balance, just as dawn is balanced by sundown but is not symmetrical to it.

Notice the narrow strand, presumably the first light of dawn, along one warp edge of the textile in figure 9. Comparable features, commonly passed off as mistakes, are observable in other pieces. *Hózhǫ́* is achieved in the way the sun rises and sets each day; by the cycle of the seasons and the years; by the different lives individuals enjoy, however parallel; by the way men and women differ physically while remaining equal in their worth.

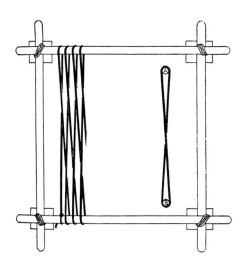

The warp is tied, double-crossed, and wrapped around two yarn beams.

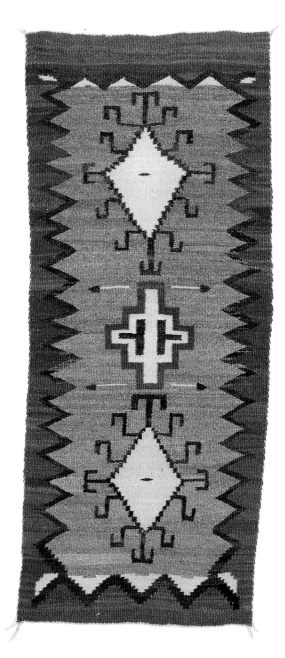

Figure 10. Rug, 1905–10. *Rather than expecting symmetry in a* diyogi, *look for traces of asymmetrical balance, which may well support dawn's early brightness and evening's dying light.*

Hózhǫ́ is not the product of identical mornings and evenings, perfectly alike days, or biological sameness in males and females. Symmetry as such does not exist in nature. The balance, or *hózhǫ́*, a weaver creates issues from her observation of reality, which she recreates at the loom. One weaver after another reported how she "put nature" into her rugs. The difficulty in understanding such a statement, however, lies in the fact that no such single word exists in the Navajo language. Instead, an elder would specify the ongoing relationship between Mother Earth and Father Sky, the activity that goes on within the four sacred mountains, the coming of light at dawn or its departure at dusk.

"Each rug is like a day," advises elder Raymond Jim, whose weaver-grandmother shared much of her knowledge with him as he grew up. "Look carefully," he advises, "and you can sometimes see emerging dawn where a weaver begins her work and where she finishes a touch of darkness. While she may not wish to be heard," he adds, "a weaver will often sing a morning song or prayer as she starts out— sometimes marked by a strand of white or some other lighter shade at the starting end, offset by a darkened touch where she finishes."

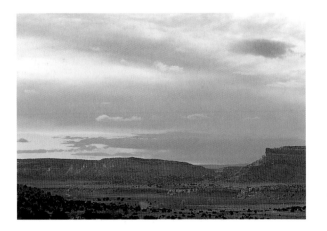

A single day marks the movement from darkness to light and back to darkness, each day being a little different since the sun rises and sets at slightly different horizontal points and at slightly different times. Older pieces sometimes start and finish with a deeper shade of yarn that lightens toward the center, "the most powerful time of day," adds Raymond Jim, "for the sun is right overhead." Sometimes a quarter of the way through a piece, a weaver subtly inserts an even brighter streak to mark a strand of cloud. Ever responsive to changes in light from minute to minute and hour to

hour, a weaver records it, avoiding symmetry
while attaining balance. Each day's light
changes in the ongoing drama of the Sun's,
relentless motion to rejoin Changing Woman,
his hard-won consort, come nightfall. As the
creation story explains, together the Sun and
Changing Woman conspire to maintain the
seasonal cycle. "We weave what we see,"
weaver after weaver repeated; frequently
they added that they also weave what they
have heard.

By showing how the thread crisscrosses
itself halfway up a newly mounted continuous
warp, weaver Marie Teasyatwho demonstrates
how each textile symbolically includes both
a male and a female half. At the bottom the
forward thread is female, she explains, while
the male is forward at the top as the warp
repeats an elongated figure eight midway
up. The two halves of a rug produce har-
mony by balancing each other in this way,
but they cannot be identical. First Woman
expresses that realization when she fashions
a mutually complementary male and female

anatomy so that men and women can give each other pleasure while conceiving offspring, impossible if male and female were the same.

In traditional Navajo thought, to weave absolute symmetry into a rug is to suspend the sun's progress through the daytime sky, to end time's cyclical motion, to halt Mother Earth and Father Sky's ongoing cosmic dance, to end procreation. To take asymmetry to extremes, however, by allowing one component to clash with another, is to produce destructive imbalance—to reverse the movement of the sun, to undo the work of creation, to leave no room for egress by closing a circle, to make a mockery of producing offspring. That is what First Man and First Woman nearly do when they quarrel over their newly fashioned sexuality. At first lacking the wisdom to keep it in balance, they separate and crave sexual gratification singly, bringing monsters into the world. Before they can reconcile, they must learn how to manage their underlying differences. Coyote, too, practices sexual abuse and brings about disorder by exploiting the difference between his four-legged species and a five-fingered, upright maiden.

A good weaver can observe *hózhǫ́* by arranging small differences into a large pattern, as they are organized in such traditional pieces as shown plate 10. For example, look at the parallel black lines crossing the horizontal block bands midway through the bottom half; note how there are no corresponding lines for its counterpart toward the top. Notice, too, the inverted sequence of figures along the edges of the medial band. Look further for smaller and more subtle variations that produce a broadly balanced impression of symmetry. Christine Martin associates this piece with Navajo recovery following the Long Walk; like many other pieces we saw, this was woven to be used ceremonially.

There are small, noteworthy features in other items. See how the subtle differences produce a visual rhythm of sorts, similar to the cyclical variation evident in sand paintings and the measured variations in prayers and chants. Not always easily noticed initially, such rhythms emerge with careful observation, suggesting movement where none at first may seem apparent (plate 4). Look for the wider white band toward one warp edge; see how the multicolored triangles woven into the stripes reveal small contrasts from one side to the other. Match with that the slender white strands woven through some of the blue ones, much like wisps of cloud might cross sections of blue sky as a day progresses with the moving sun.

In the natural order of things, the ongoing struggle for *hózhǫ́* never ends. It can be seen in the cycles of days, months, seasons,

and years; in the stories of departure, ordeal, rescue, and return; in the everyday rhythm of each person's life beginning at birth and continuing through death; in the patterned movement of all things celestial and earthbound. Such effort makes its way into the rugs abstractly and representationally, through what a traditional weaver often thinks and sometimes says, intentionally or otherwise, as she participates in a culture whose worldview is complex, complete, and alive with deep, abiding wisdom.

V. A WORLD IN MOTION: LIVING IN A DYNAMIC LANDSCAPE

"Sheep, dye, plants, animals, weavers, men, women, horses, riders—it all comes together in the loom," agrees ninety-two-year-old Willie Becenti from White Rock, New Mexico, where he and his wife, Nellie, live by choice an entirely traditional life. They carry their own water, butcher their own meat, grow their crops, and process their yarn. His has been a life of horses; hers a life of weaving. He rides still, herding sheep and cattle from a mount. As a boy he learned from his grandfather and father to break horses and train them. He spent time on the rodeo circuit and participated in Navajo-style horseraces; he drove cattle for Anglo ranchers, work that kept him away from home for days. Nellie still makes saddle blankets for him, and he has his

favorites, which he sits on in his pickup truck when not astride a saddle.

Nellie remembers learning from her grandmother that when a rider wanted a powerful or strong horse, the weaver would work into a saddle blanket a sliver of sinew from a cougar or a wildcat or even a squirrel. A small piece of feather from an eagle or a hummingbird would give a horse speed and buoyancy much needed in rodeo competition or in a race. What was incorporated in the blanket had to be small enough to be practically invisible, though, for no rider wanted his opponents to know how his mount achieved such speed.

"Young people today, they forget how important horses were back then," complains Willie. "They have vehicles now. But back then, when things were really holy, there were prayers for horses, prayers for all animals, prayers for the plants used in the dye the weavers would put into their yarn," he said. "The weaver always knew what to put into a saddle blanket to make a horse respond to its rider," he added. His grandfather had special paraphernalia that he applied to his horses

SHIKEE' SHÁÁDIŁIIŁ
SHIJÁÁD SHÁÁDIŁIIŁ
SHATS'ÍÍS SHÁÁDIŁIIŁ
SHÍNI' SHÁÁDIŁIIŁ
SHINÉ SHÁÁDIŁIIŁ

MY FEET FOR ME RESTORE.
MY LEGS FOR ME RESTORE.
MY BODY FOR ME RESTORE.
MY MIND FOR ME RESTORE.
MY VOICE FOR ME RESTORE.

Prayer from Nightway Ceremony showing repetition with single-syllable increments of change suggesting repetitive motion of weaving. From Diné bahané: The Navajo Creation Story.

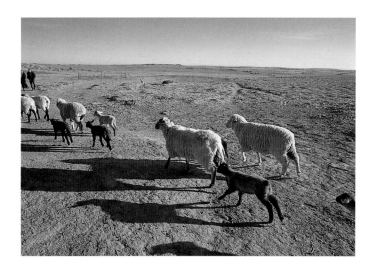

Herd at Becenti, New Mexico

"up the legs, the tail, the back," singing and praying all the while, the way a weaver sang as she worked.

Until well into the 1950s and even the 1960s, in places on the Reservation as remote as White Rock or Pueblo Pintado, where the nearest paved roads were fifty or sixty miles away, horses were the primary means of transportation. From the time it was introduced into Navajo life, owning a horse brought prestige, securing for its owner a place of importance in a society to which raiding and racing mattered. Much of the horse's allure to Navajos came from the way it allowed a motion-oriented people, who recognize a dynamic, motion-filled world around them, to move swiftly and widely.

If movement through the expanse of earth and sky helps to maintain *hózhǫ́*, so people must also stay in motion to keep order in their own lives. Changing Woman prepares to create human life in her home far to the west by dancing from an eastern mountain one day, to a southern mountain the next day, then to a western one the following day, and finally to a northern one. While awaiting instructions to bring people into the world, her sister *Yoołgai asdzą́ą́,* the White Shell Woman, likewise moves from peak to peak in the same sunwise direction. In following that circuit, they set standards for weavers, whose patterns strike a balance between no change at all and undisciplined motion.

Analogous to traveling on horseback, working at the loom involves constant motion whereby progress occurs rhythmically and the whole process depends on cycles of activity. The sheep must be cared for year-round. There is shearing to be done; wool to be carded and spun; dyestuffs to be gathered and prepared. Family members are in motion while going about their daily business or attending to special needs, sometimes within the four mountains that mark the boundaries of the Navajo world and sometimes beyond. Distant travel involved risk and uncertainty, so a weaver made a saddle blanket with special awareness. Etta Chavez of White Rock, New Mexico, for example, remembers that making one for her father was quite different from weaving an ordinary rug to sell to a trader. She put more effort into it, "a tighter weave, maybe, or a better design." As she

wove, she thought about his trips; she wanted him to sleep comfortably on the blanket; she wondered how long and how far he would travel with it; she wished for his safe return. It was when she recalled such things that she added, "Everything I was, I put into what I wove." There, too, the all-important hózhǫ comes into play at the loom and in its relationship with all aspects of Navajo life and the motion-filled world that envelops it with its surrounding dynamic cosmos.

As Willie Becenti says and Christine Martin intimated in what she told us, and from all that we learned by listening to other elders, it all comes together at the loom. Navajo rugs are far more than abstract designs and well-executed, colorful applications of expert technique; far more than commodities to be purchased and displayed. They are living projections of an ongoing way of life that stays the same because it changes so smoothly and that remains fixed in its special part of the world because it embraces dynamic motion. Organic offspring of a living tradition, the rugs have much to tell anyone patient enough to gather knowledge from the culture that bears them and attentive enough to hear what they say

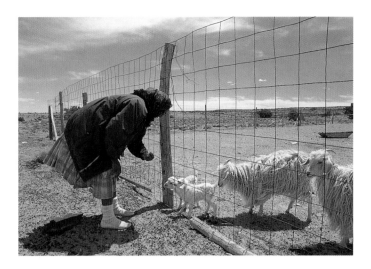

Annie James, Standing Rock, New Mexico

about a storied past. This they do in testimony to an assured future.

Ultimately, the textiles belong to the weavers. During one conversation, Etta Chavez and Loretta Benally could not estimate how many rugs they thought they had sold and where they might be now. Asked further how they felt about having them vanish to places unknown, both replied that they often wonder themselves where the rugs might be, who now has them, who's respecting them. "I wish I could see them again," Loretta added. "They are like my children. Wherever they might be, I hope they are bringing beauty into the lives of the people they are with."

I. The Mythic Memory:

Earth, Sky, and the

Holy People

THE ANCIENT PAST SURVIVES TO THIS DAY, CONVEYED BY THE STORIES THAT DESCRIBE THE EXPLOITS OF SUCH HOLY PEOPLE AS *AŁTSÉ HASTÍÍN*, THE FIRST MAN, AND *AŁTSÉ ASDZ*Ą́Ą́, THE FIRST WOMAN; *NA'ASHJÉ'II ASDZ*Ą́Ą́, THE SPIDER WOMAN, AND *NA'ASHJÉ'II HASTÍÍN*, THE SPIDER MAN; *BITS'ÍÍS ŁIZHIN*, THE BLACK BODY, AND *BITS'ÍÍS DOOTŁ'IZH*, THE BLUE BODY; AND THE WARRIOR TWINS, *NAAYÉÉ NEIZGHÁNÍ*, THE MONSTER SLAYER, AND *TÓBÁJÍSHCHÍNÍ*, BORN FOR WATER. BLANKETS AND RUGS, WHICH RESONATE WITH THE OLD NARRATIVES, ARTICULATE THAT PAST. A WEAVER COULD BE AS MUCH A KEEPER OF RECORDS AS A MEDICINE MAN OR A STORYTELLER, AND MANY ELDERS REINFORCE THAT RECORD BY RECALLING THE OLD STORIES. SOME SPOKE OPENLY ABOUT THOSE NARRATIVES, SOME MORE GUARDEDLY, ESPECIALLY OUTSIDE THE WINTER STORYTELLING SEASON, WHICH OCCURS BETWEEN THE FIRST FROST NEAR THE END OF OCTOBER AND THE COMING OF SPRING, WHEN THE SNAKES AND SPIDER PEOPLE END THEIR WINTER HIBERNATION. BUT THEY ALL KNEW THOSE TALES AND APPLIED THEM TO THE WEAVING THEY DID OR TO THE *DIYOGÍ* THEY SAW.

THE SUN AND CHANGING WOMAN UNITE
WITH THE COMING OF DARKNESS.

ELDERS ASSOCIATE THE MEDIAL ALIGNMENT OF CROSSES WITH THE STARRY SKY AS NIGHTLY DARKNESS CYCLES BETWEEN DAWN AND SUNRISE. THE CLOSED ZIGZAGS REPRESENT CONSTELLATIONS, WE HAVE BEEN TOLD, WHILE THE OPEN ONES SIGNIFY THE DAWN. MEDICINE MEN RECOGNIZE IN THIS PIECE SOMETHING LARGER—THE ESSENCE OF MALE AND FEMALE IN A WORLDVIEW WHEREIN GENDER IS ALIGNED WITH COSMIC FORCES. THE "PLUS SIGN," CONFIDED MEDICINE MAN BLACKHORSE MITCHELL, "REPRESENTS THE KIND OF UNITY AND STRENGTH THAT CAN EXIST WHEN A WOMAN AND A MAN FORM THE MALE-FEMALE BOND OF *SÁ'AH NAAGHÁÍ*, OR LONG LIFE, AND *BIK'EH HÓZHǪ́*, OR HAPPINESS. BETWEEN SEXES EQUITY MUST PREVAIL IF THERE IS TO BE HARMONY IN THE WORLD." OBSERVE HOW THE SEQUENCE OF COLORS VARIES IN A VISUAL RHYTHM FROM ONE HALF OF THE RUG TO THE OTHER. "AS DIFFERENT AS WE ARE, YOU AND I, WE ARE OF EQUAL WORTH," *ASDZ ǪǪ́ NÁDLEEHÉ*, THE CHANGING WOMAN, TELLS *JÓHONAA'ÉÍ*, THE SUN, IN STIPULATING WHAT HE MUST DO IF HE WANTS HER TO LIVE WITH HIM AND GREET HIM EACH EVENING WHEN HE COMPLETES HIS DAILY JOURNEY ACROSS THE SKY. "AS UNLIKE EACH OTHER AS YOU AND I ARE, THERE MUST ALWAYS BE SOLIDARITY BETWEEN THE TWO OF US." IN THE OVERALL FRAMEWORK OF THE EMERGENCE NARRATIVE, THEIR UNION MARKS A SHARP CONTRAST WITH THE QUARREL THAT FIRST DIVIDED *ALTSÉ HASTÍÍN*, THE FIRST MAN, AND *ALTSÉ ASDZ ǪǪ́*, THE FIRST WOMAN, AND IS SOMETHING OF A CLIMAX IN ESTABLISHING HARMONY BETWEEN MALE AND FEMALE. MOST OLDER TEXTILES SHOW SOME DEGREE OF CONTRAST BETWEEN ONE HALF AND THE OTHER. MANY ELDERS HAVE VERIFIED THAT EACH RUG HAS A FEMALE SIDE AND A MALE SIDE, EXPLAINING THE COMPLEMENTARY VARIATION BETWEEN THEM. DETAIL SHOWS NONWOOL FIBERS THREADED INTO THE WEFT.

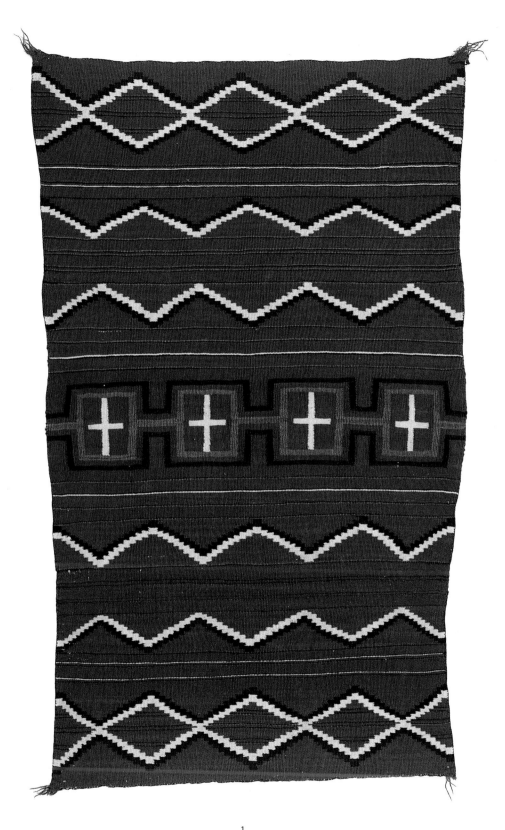

1

CATALOGED AS A SADDLE BLANKET

(POSSIBLY A CEREMONIAL PIECE ASSOCIATED WITH THE SKYWAY CEREMONY)

1914, 28" x 48"

WEAVING BEGINS IN A LOWER WORLD
WHEN SPIDER MAN AND SPIDER WOMAN
INTRODUCE THE HOLY PEOPLE TO THE
LOOM AND THE PATTERNS IT MAKES.

YES, THESE ARE SPIDERS, THE WEAVERS ALL AGREED—SOME RELUCTANTLY, FOR THE SACRED AND POWERFUL SPIDER PEOPLE MUST BE SPOKEN OF WITH RESTRAINT. IN A LOWER WORLD, CONFIDED ONE MEDICINE MAN, THE HOLY PEOPLE VENTURED INTO THE UNDERGROUND DOMAIN OF SPIDER WOMAN, *NA'ASHJÉ'II ASDZÁÁ*, AND SPIDER MAN, *NA'ASHJÉ'II HASTIIN*. THERE, AS PART OF AN EMERGING AWARENESS, THEY OBTAINED THE SPIDERS' WEBBED PATTERNS ALONG WITH THE WEAVING SKILL, WHICH WAS EVENTUALLY PASSED ON TO HUMANS. ACCORDING TO ONE STORYTELLER, THAT COUPLE BROUGHT THE LOOM FROM ONE OF THE LOWER WORLDS AS THE PEOPLE CLAMORED TO ESCAPE THE WATERS OF A RAMPAGING FLOOD. SEVERAL ELDERS ACKNOWL-

EDGED THAT THIS PIECE WAS PROBABLY USED FOR THE ANCIENT SPIDERWAY CEREMONY, WHICH IS NO LONGER BELIEVED TO BE PERFORMED. ONE WEAVER, HOWEVER, CLAIMS TO KNOW SOME OF ITS SONGS, AND AN OLD MEDICINE MAN LIVING IN NORTHEASTERN NEW MEXICO'S CHUSKA MOUNTAINS IS SAID TO PERFORM TO THIS DAY MANY OF THE CEREMONY'S CHANTS.

NOTICE HOW THE GREEN COLORATION CHANGES FROM ONE HALF OF THIS TEXTILE TO THE OTHER. SOMETIMES MALE URINE WAS USED AS A MORDANT TO ALTER THE TINT OF A PARTICULAR COLOR. THE POWER OF THE SPIDER'S VENOM IS IN THERE, WE HAVE BEEN TOLD. ACCORDING TO ONE WEAVER, THAT GREEN COLORATION DESIGNATES *NA'ASHJÉ'II BICHEII*, OR GRANDFATHER SPIDER. NOTE THE SHORT, SLENDER LINES PROTRUDING FROM EACH OF THE CROSSES. WHY THEY ARE THERE REMAINS UNKNOWN.

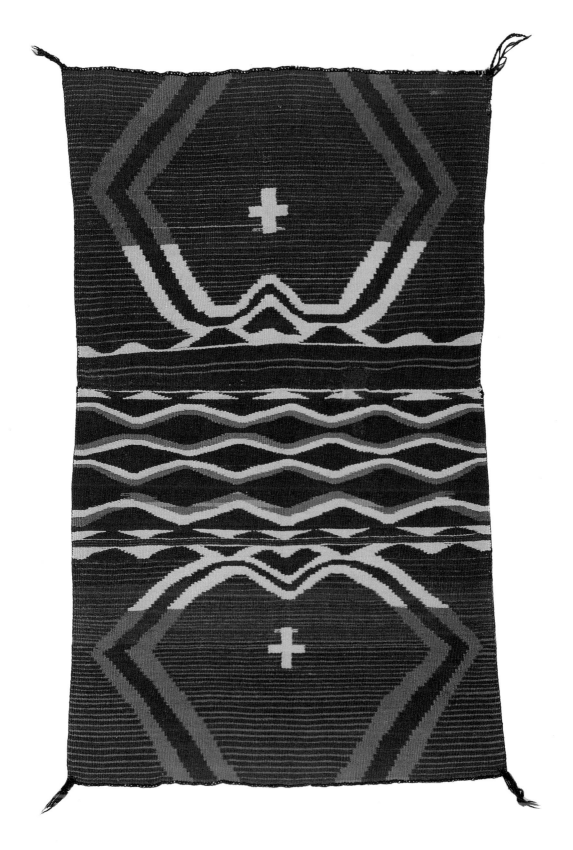

2

CATALOGED AS A SADDLE BLANKET

(PROBABLY A CEREMONIAL PIECE)

1860s–70s, 36" x 50"

INITIATORS OF THE ART OF WEAVING, THE SPIDER PEOPLE OCCUPY A CENTRAL PLACE IN CLASSIC NAVAJO THOUGHT.

WHAT SEEMS AT FIRST AN ABSTRACT DESIGN IN A *DIYOGÍ* MAY OFFER A NEW DIMENSION OF REPRESENTATION. AT FIRST WE DID NOT RECOGNIZE THE SPIDERS DEPICTED IN THIS PIECE, SO TAKEN WERE WE WITH THE PATTERN AND THE WORKMANSHIP. NOTICE HOW EACH M-LIKE FIGURE FIRST SUGGESTS ONE SPIDER THEN INTIMATES THE FULL LIKENESS OF OTHERS. UNLIKE A TRADITIONAL WESTERN ARTIST, WHO ILLUSTRATES JUST ONE VIEW OF SOMETHING, A NAVAJO WEAVER PORTRAYS A VISUAL EXPERIENCE REPEATED OVER TIME. "WE WEAVE WHAT WE SEE," THE WEAVERS SAY, IMPLYING THAT OBSERVATION IS AN ONGOING PROCESS RATHER THAN A SINGULAR EVENT.

WHEN THE ELDERS SAW THIS PIECE, THEY GENERALLY AGREED THAT IT TOLD OF SPIDERS. SEVERAL REPORTED THAT A WEAVER OFTEN BEGINS A RUG BY INVOKING *NA'ASHJÉ'II ASDZ͕ÁÁ*, THE SPIDER WOMAN, THE PATRON GODDESS OF WEAVING, AS IT WERE. BEYOND THAT, INTERPRETATIONS VARIED AS THEY OFTEN DID WHEN SEVERAL PEOPLE LOOKED AT THE SAME ITEM, MUCH THE WAY ART CRITICS VARY IN THEIR RESPONSES TO A PAINTING OR A SCULPTURE. THE STORY THE ELDERS RECOGNIZED IN THIS PIECE IS AN ACCOUNT OF HOW THE SISTER GODDESS *YOOŁGAI ASDZ͕ÁÁ* THE WHITE SHELL WOMAN, DESCENDED THROUGH THE CENTRAL "SPIDER WOMAN HOLE" TO ACQUIRE THE WEAVER'S SKILL.

WE HAVE BEEN TOLD THAT A WEAVER WILL PLACE SUCH AN OPENING NEAR THE CENTER OF A RUG IN TRIBUTE TO SPIDER WOMAN. ELDER BILLY MARTIN ASSOCIATED THIS HOLE WITH THE SOFT SPOT IN THE TOP OF A NEWBORN INFANT'S HEAD, THEREBY EQUATING WEAVING A RUG WITH GIVING BIRTH. NEARLY ALL SAID THE PARALLEL LINES ON EACH HALF—A COMMON JUXTAPOSITION WITH SEVEN LINES ON ONE HALF AND SIX ON THE OTHER—SUGGEST SPIDER WEBBING. WHEN ONE ELDER SAW THE LINES, SHE REPORTED THAT WEAVERS RUB SPIDER WEBBING INTO THEIR HANDS BEFORE BEGINNING A WORK IN ORDER TO ACQUIRE SPIDER WOMAN'S SPECIAL SKILLS.

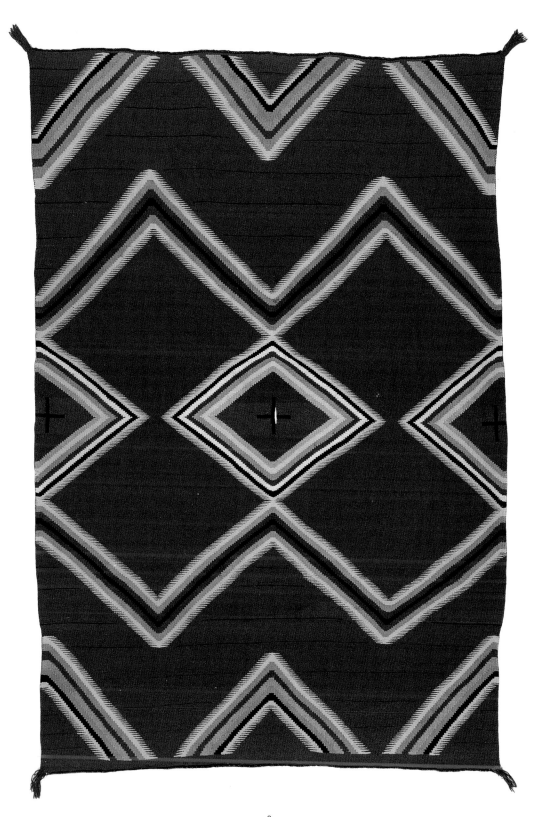

3

WEARING BLANKET

1870-75, 50"x76"

THE SUCCESSFUL RETURN OF THE
MONSTER SLAYER IS AN OCCASION
FOR SONG.

"A LONG TIME AGO," SAID ONE ELDER, "A WEAVER WOULD SING SPECIAL SONGS AND RECITE CERTAIN PRAYERS WHEN MAKING A BLANKET LIKE THIS, WHICH WAS EITHER USED FOR A PARTICULAR CEREMONY OR WORN BY SOMEONE HAVING ALREADY HAD ONE." DURING A MUSEUM VISIT, ANOTHER ELDER POINTED TO STRANDS OF NONWOOL FIBER USED DURING THE FIRST NIGHT OF AN ENEMYWAY CEREMONY, WHICH CELEBRATES THE ORDEAL AND EVENTUAL RETURN OF *NAAYÉÉ NEIZGHÁNÍ*, THE MONSTER SLAYER, FROM HIS BATTLE WITH A GROUP OF MONSTERS.

MANY TEXTILES PREDATING THIS ONE CONTAIN SUCH INDIRECT REFERENCES TO THE OLD STORIES, INDICATING THAT NONWOOL OBJECTS INSERTED IN THE RUGS SHOULD NOT BE IGNORED. MANY WEAVERS AGREED THAT THIS BLANKET IS FULL OF SONGS, APPARENT TO THEM IN CLUSTERS OF TRIANGLES ALONG THE HORIZONTAL STRIPES FROM BOTTOM TO TOP. THE *DIYOGÍ* EXPRESSES PROGRESSION, MOVEMENT, AND CHANGE EVIDENT IN A VIBRANT WORLD WHOSE ORDER IT SEEKS TO DUPLICATE. NOTICE THE VARIATION THAT SUBTLY SETS OFF ONE HALF OF THE BLANKET AGAINST THE OTHER. SYMMETRY IS AVOIDED IN TRADITIONAL RUGS AND BLANKETS, FOR SUCH SAMENESS MAKES THE LOOM DEADENINGLY STATIC.

LOOK FOR THE STITCHING IN ONE OF THE SEVERAL THUMBNAIL-SIZED RAISED SURFACES. THE ELDERS WHO SAW THIS *DIYOGÍ* INDICATED THE STITCHING COULD REPRESENT A CLUSTER OF STARS, SUCH AS THE PLEIADES, OR A CONSTELLATION. CENTERED IN THE WIDER WHITE BAND TOWARD THE TOP WEFT EDGE IS A FAINT PASTEL LINE CALLED *TÉLII' AK'ÁÁN YIZGHAD,* OR DONKEY TRAIL, SO NAMED BECAUSE IT RESEMBLES THE PATHWAY A DONKEY MAKES WHEN HAULING A SACK OF FLOUR WITH A HOLE IN IT. THE SUN ALSO MAKES A SIMILAR TRAIL IN THE EARLY MORNING SOON AFTER DAWN WHEN A CEREMONY OFFICIALLY ENDS. EVEN IN TODAY'S MARKET, WHICH IS GOVERNED IN PART BY WESTERN STANDARDS OF "PERFECTION," A TRADITIONAL WEAVER MAY SNEAK IN ONE OR MORE SMALL VARIANCES.

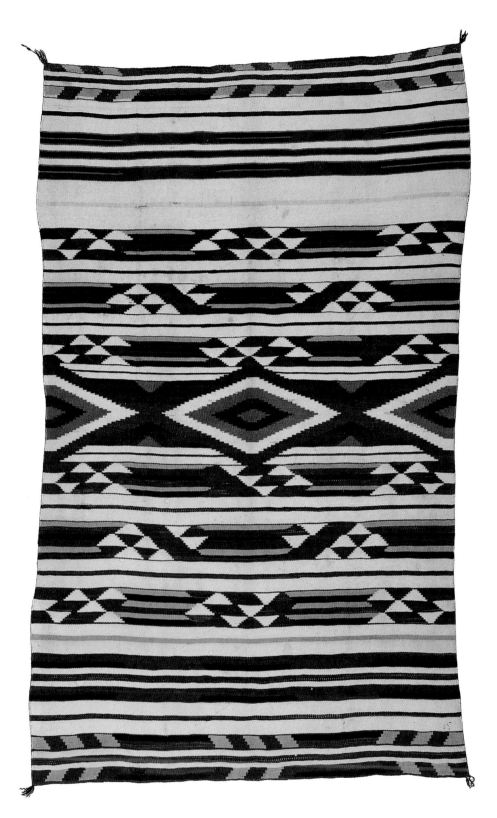

4

WEARING BLANKET

1890s, 47" x 76"

"GIVE US WEAPONS," THE WARRIOR TWINS PLEAD WHEN THEY VISIT THEIR FATHER IN THE SKY.

THIS EPISODE OF THE WARRIOR TWINS, PERHAPS THE KEY ELEMENT IN THE ENTIRE EMERGENCE CYCLE, TELLS HOW *NAAYÉÉ NEIZGHÁNÍ,* THE MONSTER SLAYER, TRAVELED SKYWARD WITH HIS TWIN BROTHER *TÓBÁJÍSHCHÍNÍ,* BORN FOR WATER, TO ASK *JÓHONAA'ÉÍ,* THE SUN, TO HELP MAKE THE WORLD SAFE FOR HUMANS. "GIVE US WEAPONS SO THAT WE MAY RESIST THE MONSTERS," THEY PLEAD. "GIVE US WEAPONS SO THAT WE CAN DESTROY *YÉ'IITSOH,* THE BIG GIANT, AND HIS FOLLOWERS." INDEED, THE ARROWS THEY RECEIVED ARE REPRESENTED IN THIS PIECE.

A DEEPLY SACRED STORY RECITED ONLY DURING WINTER, IT REMAINS CONSISTENT FROM VERSION TO VERSION, INDICATING ITS IMPORTANCE NO MATTER WHO TELLS IT. VIRTUALLY EVERY ONE OF THE ELDERS WE TALKED WITH DECLINED TO DISCUSS THE WARRIOR TWINS' TALE OUTSIDE THE TRADITIONAL STORYTELLING SEASON.

TYPICAL OF THE WAY OLDER RUGS VARY, THIS *DAH'IISTŁ'Ǫ́* EXHIBITS SUBTLE DIFFERENCES FROM ONE PANEL OF WEAPONS TO THE NEXT, REGISTERING PROGRESSION IN THE WAY THE TWIN BROTHERS MADE THIS WORLD SAFE FOR ITS HUMAN OCCUPANTS AND IN THE CONSTANT SHIFT OF LIGHT AS EACH DAY COMPLETES ITS CYCLE FROM SUNRISE TO SUNSET. IN THIS PIECE THE LIGHT OF DAY IS REPRESENTED ALONG ONE SIDE BORDER AND THE DARK OF NIGHT IS REPRESENTED ALONG THE OPPOSITE BORDER.

POSITIONED LIKE A SAND PAINTING ON THE HOGAN FLOOR, THIS RUG WAS LIKELY USED IN THE ARROWHEAD CEREMONY FOR PEOPLE ABOUT TO GO HUNTING OR OFF TO WAR OR FOR ANYONE MAKING ARROWS. THE COMBLIKE IMAGES ON EACH END REPRESENT THE FEATHERS IN AN ARROW SHAFT. ELDERS IDENTIFIED THE GREEN SPOT AT ONE END OF THE RUG (DETAIL) AS A DROP OF BODY PAINT APPLIED TO THE PATIENT DURING THE CEREMONY. THIS SPOT WAS MADE WITH THE SAME GREEN DYE SEEN IN THE BOWS AND ARROWS. THE WORN AREAS INDICATE WHERE THE PATIENT PUT HIS HANDS AND FEET.

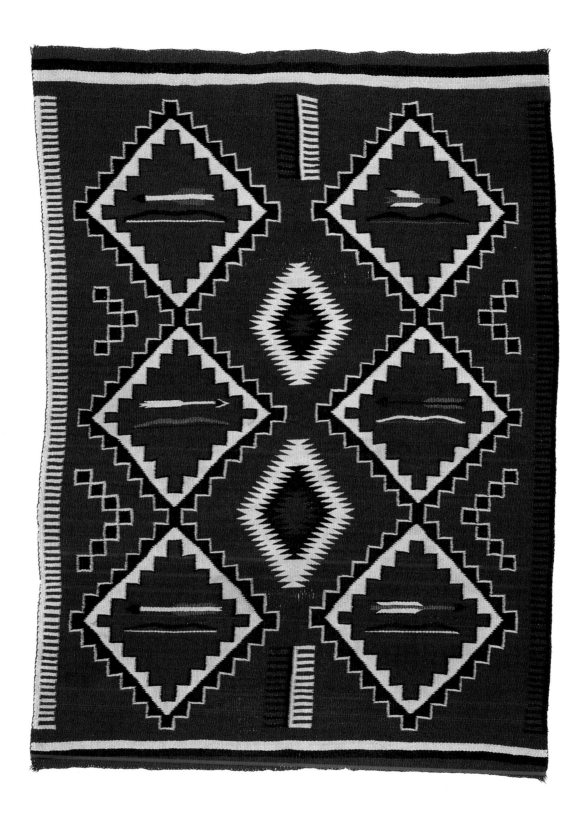

5

WARRIOR RUG, CATALOGED AS A BLANKET
(PROBABLY A CEREMONIAL PIECE)

EARLY 20TH CENTURY, 52" x 68"

II. The Collective Memory: Exile, Return, and the Outside World

FOLLOWING THE FORT SUMNER CAPTIVITY AND RELEASE (1864–66), WEAVERS BEGAN TO RECORD THAT EXPERIENCE, ALONG WITH THE EUROPEANS' ARRIVAL IN NAVAJO COUNTRY. HAVING HEARD STORIES FROM THEIR PARENTS AND GRANDPARENTS ABOUT THE ILLNESS AND HUNGER, THE LONGING TO RETURN TO *DINÉBIKÉYAH*, AND THE DESOLATION THEY FOUND UPON RETURN-ING, THE ELDERS TOLD OF IT AS IF THEY HAD LIVED IT THEMSELVES. THAT ADVERSITY WAS TO STRENGTHEN THEM AS A PEOPLE BY GAL-VANIZING THEIR COMMONLY SHARED PAST AND INCREASING THEIR DETERMINATION TO SURVIVE.

"THE ORDEAL OF THE LONG WALK HAS MADE US A STRONGER PEOPLE."

"TEARS," SAY WEAVERS ANNIE MORRIS, RITA COWBOY, AND OTHERS UPON SEEING THE WHITE DROPS EXTENDING FROM THE LONG CANTILEVERS SURROUNDING THE CONCENTRIC DIAMONDS AND THE ENCLOSING ZIGZAGS. "SONGS OF PRAYER," JUNE KALLECO CALLS THEM, REFERRING TO THE PAINFUL LONGING FOR FREEDOM. SCHOLARLY ELDER LEON SECATERO IDENTIFIES THEM AS LIGHT RADIATING OUT OF THE SKY TOWARD THE EARTH IN RESPONSE TO THOSE PRAYERS. "THE PEOPLE ARE SUMMONING POWER FROM ABOVE THE WAY FATHER SKY TOUCHES MOTHER EARTH," HE ADDS. IN THIS PIECE, ALL RECOGNIZE SUFFERING AND SEE SADNESS IN THIS OSTENSIBLE RECORD OF THE FORT SUMNER EPISODE OF NAVAJO HISTORY. ONCE WE SHARED WITH SOME ELDERS OUR SPECULATION THAT THIS PIECE WAS PRODUCED IN CONNECTION WITH FORT SUMNER, IT AROUSED MEMORIES OF WHAT THEY WERE TOLD BY THOSE WHO HAD ENDURED THAT ORDEAL. OTHERS MADE THE ASSOCIATION INDEPENDENTLY.

A NUMBER OF ITEMS WOVEN DURING THE TRANSITIONAL PERIOD APPARENTLY RECORD THAT TERRIBLE EVENT FOR COMMEMORATIVE OR CEREMONIAL USE. THE ELDERS CONSIDER THIS PIECE ONE OF THEM AND OFFER A WIDE RANGE OF INTERPRETIVE COMMENTARY. ALL AGREED THAT THE BOWS AND PARALLEL LINES COMBINE TO REPRESENT FREEDOM AND RAIN. WITH OTHERS, LORETTA BENALLY BELIEVES THAT THE RED FLANNEL PROBABLY COMES FROM OFFICERS' UNDERCLOTHING, WHICH SOME OF THE WOMEN MANAGED TO OBTAIN. "WHEN YOU WANT TO WEAVE BADLY ENOUGH," ADDED HARRY BURNSIDE, "YOU FIND WOOL NO MATTER HOW."

THE CENTRAL MOTIF DREW THE BROADEST SET OF COMMENTS, DEMONSTRATING THE NAVAJO CAPACITY FOR AGREEING ON THE MEANING OF AN INDIVIDUAL SYMBOL OR SINGULAR MYTHIC OR HISTORIC EVENT AND ACCEPTING DIVERGENT EMBELLISHMENTS. MATTHEW AND NELLIE SUCCO OF WHITE ROCK, NEW MEXICO, BOTH IN THEIR EIGHTIES, IDENTIFIED THE IMAGE AS A BIRD WITHOUT SPECIFYING A SPECIES; CHRISTINE MARTIN NAMED THE EAGLE, THEN ADDED THAT THE ENCLOSING DOUBLE DIAMOND SPECIFIES IMPRISONMENT. "THE ENCLOSURES HAVE TO SIGNIFY IMPRISONMENT," AGREE HARRY BURNSIDE AND HIS WIFE ANNIE, "OTHERWISE THERE WOULD BE A BREAK IN EACH." BUT THE FIGURE INSIDE "COULD SYMBOLIZE THE ENEMY, THE MILITARY, PLACED WITHIN . . . AS A MEANS OF RETRIBUTION."

WHILE WE WERE SHOWING THIS PIECE TO A GROUP OF VISITING COLLEGE STUDENTS, ONE OF THEM NOTICED A SMALL FIBROUS CONFIGURATION WOVEN INTO IT. ASKED ABOUT IT LATER, HARRY BURNSIDE SAID THAT WHEN A BLANKET IS WOVEN WITH INSERTIONS SUCH AS THIS, HARM CANNOT BEFALL THE WEARER. WHEN LEON SECATERO SAW IT, HE CONSIDERED THE FIGURES REPRESENTATIVE OF TWO BABIES WHOSE RETURN TO THE LAND BETWEEN THE FOUR SACRED MOUNTAINS WAS YEARNED FOR. WITH EACH NEW INTERPRETATION, THIS *DAH'IISTŁ'Ǫ* BECOMES ALL THE MORE POIGNANT, DEMONSTRATING HOW THE NAVAJO PEOPLE SHARE A DYNAMIC SENSE OF HISTORY.

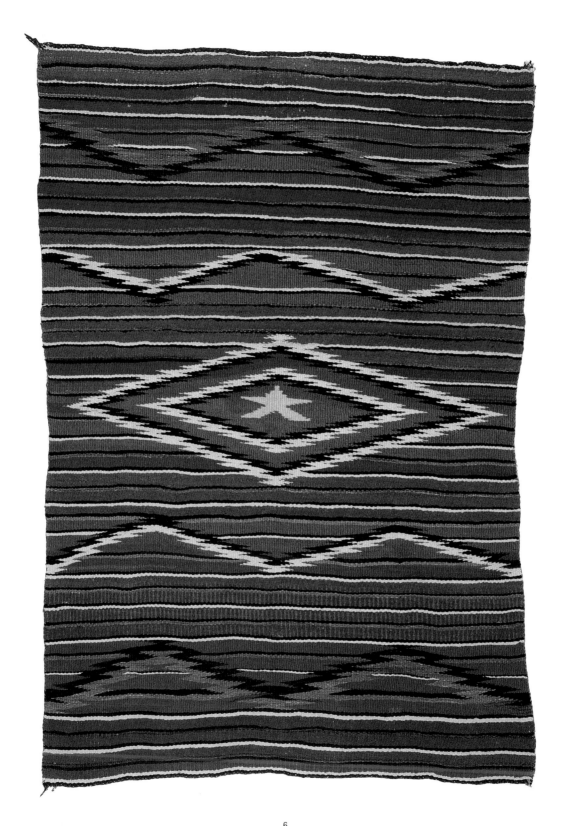

6

CATALOGED AS A LATE CLASSIC SERAPE
(POSSIBLY A COMMEMORATIVE PIECE MARKING THE FORT SUMNER EXPERIENCE)

1875–80 OR POSSIBLY EARLIER, 48" x 68"

WITH WEAVING WE OVERCOME THE
BITTER EFFECTS OF CAPTIVITY.

WHEN A GROUP OF VISITING WEAVERS FIRST SAW THIS
RUG, THEY FELL INTO A DEEP SILENCE OF PRAYER AND REFLECTION.
SOME HESITATED TO SPEAK AT ALL, WHILE OTHERS RESPONDED
SLOWLY. CHRISTINE MARTIN SAID IT IS A SPECIAL PIECE SHE KNEW
OF AND HAD ALWAYS WISHED TO SEE. AS FULL OF SYMBOLIC AND
LITERAL INFORMATION AS ANY WE EXAMINED, THIS PIECE REITER-
ATES THE STORY OF THE LONG WALK TO BOSQUE REDONDO, THE
CAPTIVITY THERE, THE PEOPLE'S STRUGGLE TO RETURN TO
DINÉBIKÉYAH, AND THEIR RESOLVE TO REBUILD AS A PEACEFUL
NATION OF HERDERS, FARMERS, AND WEAVERS. ACCORDING TO
MARY BIGGS, WHO SPOKE FOR THE OTHERS, IT WAS WOVEN TO
MARK THE NEW LIVES THE PEOPLE WOULD LEAD, THEN GIVEN TO
UNITED STATES OFFICIALS AS REPARATION FOR EARLIER RAIDS.
MANY RUGS THAT WERE MADE FOR AND OFFERED TO THE
AMERICAN VICTORS AS TRIBUTE ARE NOW IN MUSEUMS.

MAKING A RUG OF THIS SIZE WAS DIFFICULT, ADVISED SIS-
TERS JUNE KALLECO AND SARAH JOHNSON, ACTIVE WEAVERS
WHO MAINTAIN TRADITIONAL WAYS THEY LEARNED FROM THEIR
GRANDMOTHER. THE BACK OF A WAGON WAS NECESSARY TO
SUPPORT A SUFFICIENTLY LARGE LOOM, WHICH WAS TOO CUM-
BERSOME TO ERECT EASILY. JUNE DEMONSTRATED HOW A WOMAN
WOULD POSITION HERSELF AT THE GIANT LOOM AND EXTEND HER
REACH AS FAR AS POSSIBLE TO COMPLETE A SECTION WHILE
KNEELING OR SITTING ON A LOW STOOL.

THIS PIECE IS A CATALOG OF WOVEN SYMBOLS, RANGING
FROM THE COLORS AND BROAD IMAGES TO THE SMALL FEATURES
AND SUBTLE CONTRASTS. IT CONTAINS NUMEROUS SONGS AND
PRAYERS ABOUT MAINTAINING THE OLD PATTERNS AND DESIGNS,
AND IT IS FULL OF PEACEFUL THOUGHT AND SACRED EXPRESSION
ADDRESSED TO SOMEONE VERY IMPORTANT.

THE SPLIT TRIANGLES ALONG EACH EDGE HAVE BEEN IDEN-
TIFIED AS FOOTPRINTS, SUGGESTING THE LONG WALK AND MAYBE
EVEN THE ATIIN DIYINII, OR HOLY TRAIL, THAT THE WARRIOR TWINS
FOLLOWED IN MAKING THEIR WAY TO JÓHONAA'ÉÍ, THE SUN. THE
BICOLORED RECTANGLES ALONG EACH EDGE REPRESENT THE
RAINBOW, WHOSE PATH THE TWINS FOLLOWED. THE RED-AND-
WHITE FENCE POST–LIKE SQUARES DESIGNATE CONFINEMENT, NOT
ONLY OF THE NAVAJOS IN CAPTIVITY BUT OF SHEEP IN CORRALS.
THE TRIANGLES MOVING INWARD FROM THE EDGES PEAK AT THE
CENTER AS THEY DO IN PLATE 8. THEIR PATHWAYLIKE QUALITY
EXPRESSES HOPED-FOR SUCCESS FOR CHILDREN, WHO ARE TO BE
ENCOURAGED TO ATTAIN KNOWLEDGE IN THEIR NEW LIFE. THE
SMALL COMBS AT THE PEAKS OF THE WHITE STAIRED TRIANGLES
THAT JUT INWARD FROM EACH END SIGNIFY WEAVING AS ONE
MEANS OF SUCCEEDING.

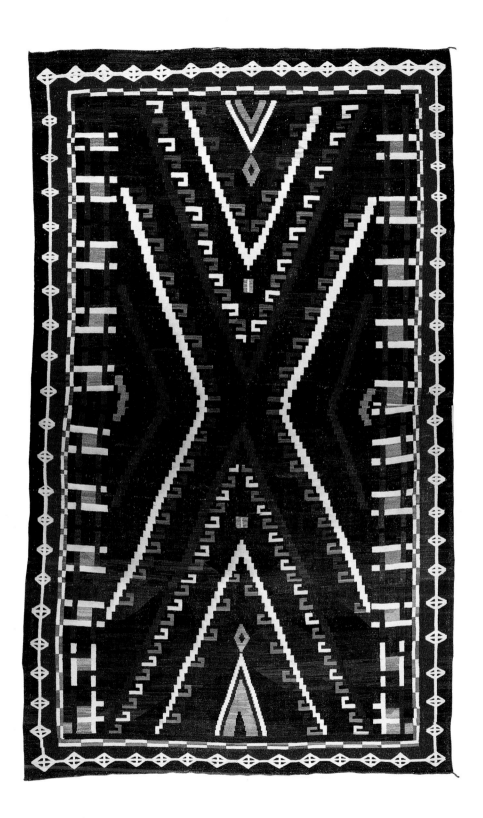

7

CATALOGED AS A RUG

(IDENTIFIED BY ELDERS AS A TRIBUTE PIECE)

1900 OR EARLIER, 114" x 187"

IN THE ORDEAL OF THE LONG WALK, MYTH AND HISTORY COMBINE AS LIVING MEMORY.

IN CLASSIC NAVAJO THOUGHT, HISTORY IS DYNAMIC AND ALIVE. MYTHIC TIME RECYCLES ITSELF IN RECORDED HISTORY, WHILE THE REMEMBERED PAST IS REINVESTED IN THE PRESENT. THE ORDEAL OF THE WARRIOR TWINS IS REENACTED IN THE LONG WALK INTO AND AWAY FROM CAPTIVITY AT BOSQUE REDONDO. BOTH TREKS HAVE BEEN STAMPED INTO THE MEMORIES OF TRADITIONAL WEAVERS, ESPECIALLY AS THE TWO EVENTS MERGE AGAIN AND AGAIN IN CEREMONIES RE-CREATING HAZARDOUS JOURNEYS OF EXILE AND RETURN.

DURING A LATE SPRING CONVERSATION, MINNIE BECENTI WAS ASKED IF THE BARBED FIGURES ALONG EACH EDGE WERE THE SLASHING REEDS THE TWINS HAD TO MAKE THEIR WAY THROUGH ON THEIR HARROWING JOURNEY INTO THE SKY. SHE HESITATED TO AGREE OUTRIGHT, THOUGH; SHE WAS AMONG THOSE RELUCTANT TO TALK ABOUT THE VISIT TO *JÓHONAA'ÉÍ*, THE SUN, FOR THE STORYTELLING SEASON WAS OVER. SHE RECOGNIZED IN THE POINTED PROTRUSIONS PEOPLE WALKING, VERY LIKELY MAKING THEIR WAY TO FORT SUMNER AND STRUGGLING TO RETURN TO THEIR HOMELAND.

WHEN ASKED TO ALIGN THE MYTHIC EPISODE WITH THE REMEMBERED EVENT, MINNIE OFFERED ONLY A CRYPTIC COMMENT. "EVERYTHING MY GRANDMOTHER AND GRANDFATHER DID, IT HAD SOMETHING TO DO WITH YOUR MIND. YOUR FEET AND YOUR MIND HAVE TO BREATHE," SHE SAID. SUCH A COMMENT, HOWEVER MYSTERIOUS, SUMMARIZES THE INTELLECTUAL ENERGY MANIFEST IN WEAVINGS SUCH AS THIS ONE AND PUT INTO ACTION IN CEREMONIES. TO SUMMON SHARED MEMORIES IS TO ACTIVATE MIND AND BODY ALIKE.

IN DISCUSSIONS OF WEAVING THAT EMPHASIZE ONLY TECHNIQUE AND QUALITY OF WORKMANSHIP, IT IS ALL TOO EASY TO OVERLOOK THE INTRINSIC VALUE OF A PIECE SUCH AS THIS, WHICH SHOWS WEAR AND APPEARS TO HAVE IRREGULARITIES. THE FRAYED EDGE AT THE TOP MAY INDICATE WHERE A PATIENT PUT HIS OR HER FEET IN A CEREMONIAL REENACTMENT OF DELIVERANCE FROM IMPENDING DESTRUCTION. WHEN CONSIDERED WITH THE CHANTWAYS AND WITH THE STORIES TOLD AND RETOLD, ALL ASPECTS OF A PIECE TAKE ON ADDED EXPRESSIVENESS.

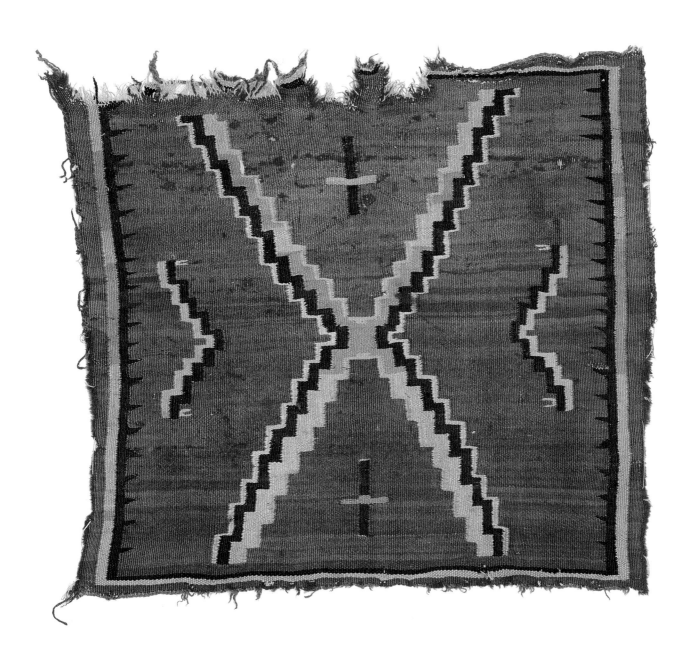

8

CATALOGED AS A SADDLE BLANKET

(POSSIBLY A CEREMONIAL OR COMMEMORATIVE PIECE)

LATE 19TH CENTURY OR EARLIER, 32" x 28"

**"BEWARE OF TRAINS!"
THE CHILDREN WERE WARNED.**

ASKED TO TELL ABOUT THE COMING OF THE RAILROAD TO THE AREA WHERE SHE GREW UP, RUTH SANCHEZ REMINDED US OF THE NAVAJO WORD FOR TRAIN, *KO' NA'AŁBĄĄSII,* AND ITS LITERAL MEANING, "ENGINE THAT RUNS WITH A FIRE." ALTHOUGH UNSURE OF HER EXACT AGE, SHE KNOWS SHE IS OLDER THAN EIGHTY. SHE REMEMBERS HOW HER GRANDPARENTS TALKED ABOUT THE FIRE AND SMOKE THAT LOCOMOTIVES MADE. TRAINS "FRIGHTENED THE PEOPLE WHO FIRST SAW THEM. AND SO DID THE PASSENGERS THEY BROUGHT "—THE *BITSII' DALTSOOÍ,* OR YELLOWHAIRS, WHO "HINDERED A LOT OF PEOPLE'S GRAZING RIGHTS." BEFORE SHE EVER SAW A TRAIN HERSELF, RUTH'S GRANDMOTHER TRIED TO DESCRIBE ONE "WITH ALL THOSE WHEELS, ALL THAT NOISE." "BE CAREFUL OF TRAINS," SHE WAS TOLD AS A CHILD. "SOMETIMES THEY TAKE CHILDREN AWAY, NEVER TO BE SEEN AGAIN." TO THIS DAY, TRAINS MAKE HER HEART BEAT WITH FEAR.

TO OUTSIDERS, TRAIN PICTORIALS TRANSMIT A CERTAIN CHARM; OFTEN, HOWEVER, THEY RECORD A NAVAJO AMBIVA-LENCE TOWARD LOCOMOTIVES AND THE PEOPLE AND GOODS THEY BROUGHT. REPRESENTATIONS OF ARTICLES NEWLY INTRODUCED FROM THE OUTSIDE WORLD COMBINE WITH TRADITIONAL ELE-MENTS OF DESIGN IN A FUSION OF STYLE AND CONTENT. IN THIS BLANKET, TWO TRAINS TRAVERSE A BACKGROUND OF INDIGENOUS LINES AND FIGURES, ILLUSTRATING THE ARRIVAL OF THE RAILROAD IN NAVAJO COUNTRY. THE TRAINS BRING MANUFACTURED ITEMS, SUCH AS BOOTS AND WIDE-BRIMMED HATS, AND DOMESTIC ANI-MALS, SUCH AS CHICKENS AND COWS, WHICH HAD BEEN INTRO-DUCED EARLIER.

NOTE HOW THE RANDOMLY SCATTERED HUMANS SUGGEST IMBALANCE. SOME ARE DRESSED AS ANGLOS, WHILE OTHERS OBVIOUSLY REPRESENT NAVAJOS. THAT THESE FIGURES ARE NOT ALIGNED IN BALANCE THE WAY FIGURES GENERALLY ARE IN RUGS THREATENS DISARRAY. LIKEWISE, THE UNEVEN NUMBER OF HUMAN FIGURES PLACED ABOVE AND BELOW THE TRAINS ADDS TO THAT SENSE OF IMBALANCE, AS DO THE DIFFERENT LENGTHS OF THE TRAINS THEMSELVES.

A DYNAMIC ASYMMETRY THAT EXPRESSES NAVAJO THOUGHT MAY BE AT WORK IN THIS AND MANY OTHER TRADI-TIONALLY WOVEN RUGS. PRECISE MEASUREMENT REVEALS THAT THE TRAINS DO NOT DIVIDE THE RUG INTO TWO EQUAL PARTS; THE UPPER PORTION IS SLIGHTLY LONGER THAN THE LOWER PORTION. TYPICALLY, SUCH AN IRREGULARITY WOULD BE CONSIDERED A MISTAKE, BUT THE PRECISION ELSEWHERE IN THIS *DIYOGÍ* SUG-GESTS THAT THIS ARRANGEMENT IS DELIBERATE.

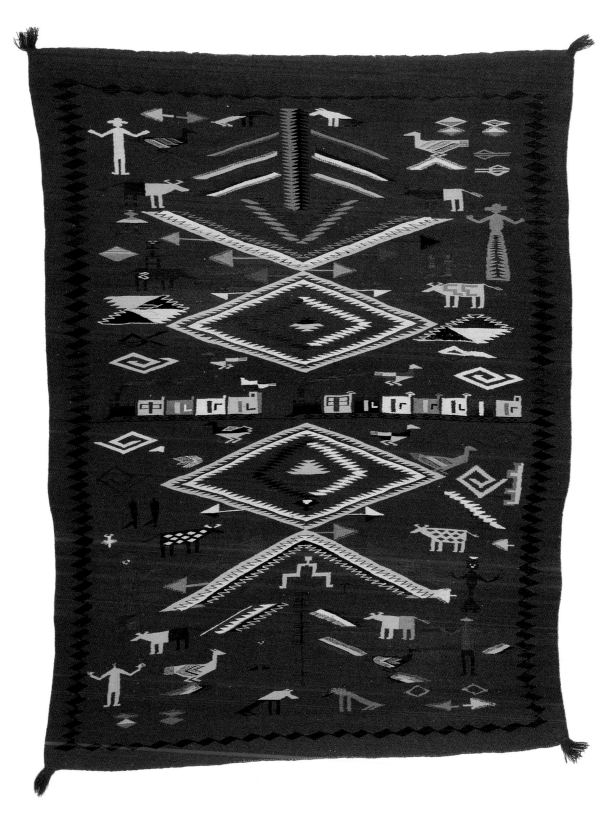

9

PICTORIAL CHIEF'S BLANKET

1875–80, 46" x 72"

EVERY SUFFERING THE PEOPLE
WENT THROUGH.

THIS PIECE WAS MADE IMMEDIATELY FOLLOWING THE
NAVAJOS' RELEASE FROM FORT SUMNER, AND IT CONTAINS
NUMEROUS EXAMPLES OF WHAT WE CALL COMPLEMENTARITY.
THIS TERM REFERS TO SLIGHT VARIATIONS ONE FINDS IN A ZONE
ON ONE HALF OF A RUG AND IN ITS CORRESPONDING ZONE ON
THE OTHER HALF. SUCH VARIATIONS ALSO ARE FOUND ON THE
OPPOSITE SIDES OF A ZONE. THESE SUBTLE CHANGES SERVE TO
UNDERMINE THE STABILITY THAT EVEN THE ILLUSION OF SYMME-
TRY OFFERS; IN FACT, COMPLEMENTARITY PRODUCES AN UNDER-
STATED AND UNIFIED ASYMMETRICAL OPPOSITION. OBSERVE HOW
A SOLID BLACK LINE CROSSES THE OUTER NOTCHED PORTION OF
THE INTERMEDIATE ZONE MIDWAY THROUGH ONE HALF OF THIS
PIECE, WHILE A SIMILARLY PLACED BLACK LINE DOES NOT CROSS
THE CORRESPONDING NOTCHES ON THE COMPLEMENTARY ZONE.
NOTICE, TOO, THE VARYING CONELIKE MOTIFS ALONG THE EDGES
OF THE MEDIAL ZONE. NOW LOOK CAREFULLY AT THE SLIGHT DIF-
FERENCES THAT OFFSET EACH OF THE FOUR ZIGZAGS.

SOME ELDERS ASSOCIATE THESE ZIGZAGS WITH LIGHTNING,
REMINDING US THAT *JÓHONAA'ÉÍ*, THE SUN, GAVE THE WARRIOR
TWINS FOUR DIFFERENT KINDS OF LIGHTNING ARROWS TO ARM
THEMSELVES AGAINST THE MONSTERS. UPON SEEING THIS RUG,

CHRISTINE MARTIN AND HER TWO DAUGHTERS, MARY BIGGS AND
BERNICE ATCITTY, IMMEDIATELY ASSOCIATED IT WITH THE LONG
WALK, RECOGNIZING IN IT NUMEROUS ELEMENTS OF TENSION
AND TRIBULATION FIXED IN THE NAVAJO COLLECTIVE MEMORY.
COMPARE THE SIMILARITY BETWEEN THE NOTCHED ROWS ABOVE
AND BELOW THE MEDIAL STRIP OF ZIGZAGS AND THE "CONFINE-
MENT SQUARES" BORDERING THE WEFT EDGES ON BOTH SIDES OF
PLATE 7. NOTE THE RESEMBLANCE BETWEEN THE BARBED TRIAN-
GLES AT EACH WARP EDGE IN THIS PIECE AND IN THE BROAD CAN-
TILEVERED ZIGZAGS AND ENCLOSING CONCENTRIC DIAMONDS IN
PLATE 6. CHRISTINE SUGGESTED THAT THIS PIECE "PROBABLY CON-
TAINS A REMINDER OF EVERY SUFFERING THE PEOPLE WENT
THROUGH."

WHEN TOLD THAT A SMALL PIECE OF FEATHER HAD BEEN
WOVEN INTO IT, CHRISTINE DISCUSSED IT EXCITEDLY WITH HER
DAUGHTERS, THEN EXPLAINED THAT IF A FEATHER FALLS FROM A
BIRD IN FLIGHT AND IS CAUGHT BEFORE IT TOUCHES THE GROUND,
THE FEATHER BECOMES A SYMBOL OF DELIVERANCE AND SHOULD
BE WOVEN INTO A RUG.

THREE WEEKS AFTER CHRISTINE MARTIN LOOKED AT A PHO-
TOGRAPH OF THIS RUG AND TEN DAYS AFTER SHE ACTUALLY SAW
IT, SHE PASSED AWAY. HER DAUGHTERS HAVE ASKED THAT WE
QUOTE HER BY NAME IN TESTIMONY TO HOW MUCH SHE KNEW.

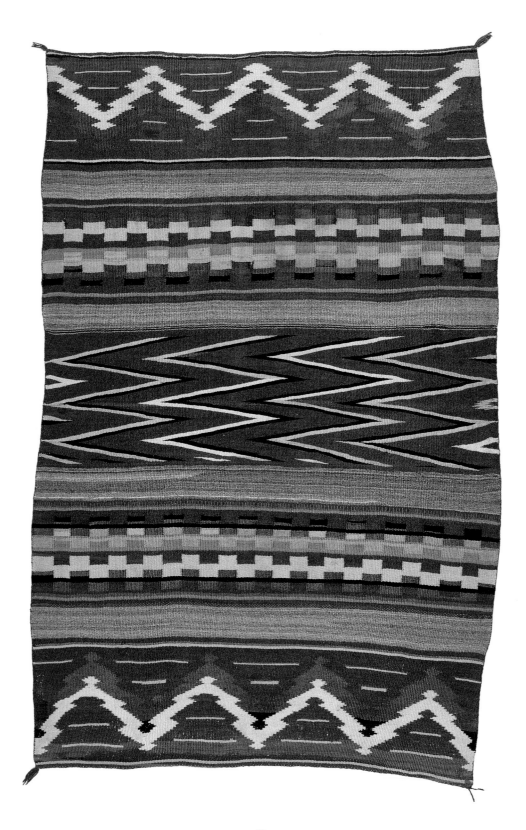

10

LATE CLASSIC SERAPE

(POSSIBLY WITH CEREMONIAL OR COMMEMORATIVE IMPLICATIONS)

1875–85, 46" x 72"

III. Ceremonial Practice:

Summoning the Holy People

IN NAVAJO CEREMONIES THE INVISIBLE WORLD IS ABSORBED INTO WHAT IS SEEN, TOUCHED, FELT, HEARD, AND TASTED. THE HOLY PEOPLE ARE CALLED FROM THEIR DWELLING PLACES TO HELP MAINTAIN HARMONY AND TO REESTABLISH IT. *ASDZÁÁ NÁDLEEHÉ*, THE CHANGING WOMAN, MAY BE INVOKED TO IMPART *HÓZHǪ* TO AN UNBORN CHILD. TO RESTORE *HÓZHǪ* TO A PATIENT EXPERIENCING PHYSICAL ILLNESS OR MENTAL ANGUISH, THE WARRIOR TWINS ARE ASKED TO ACCOMPANY THE PATIENT INTO THE SKY TO ACQUIRE WEAPONS SUITABLE FOR SLAYING HIS OR HER INNER MONSTERS. THIS SCENARIO IS SIMILAR TO A STORY SET IN PRIMORDIAL TIME IN WHICH *NAAYÉÉ NEIZGHÁNÍ*, THE MONSTER SLAYER, AND *TÓBÁJÍSHCHÍNÍ*, BORN FOR WATER, WERE NEEDED TO RID THE WORLD OF DEVOURING GIANTS. WHEN ONE LOOKS AT AN OLD RUG AND LISTENS TO WHAT THE ELDERS HAVE TO SAY, IT IS AS IF THE WEAVERS ARE STILL TELLING THE STORIES OR RECITING THE PRAYERS THAT GIVE A CEREMONY ITS MEANING.

"REMEMBER," CONFIRMS LORETTA BENALLY, "BACK THEN, BEFORE WE HAD VEHICLES AND ELECTRICITY, THERE WERE ALWAYS CEREMONIES BEING PERFORMED. EVERY NEIGHBOR HAD SOME KIND OF CEREMONY GOING." WHEN SUNDOWN CAME, THEY PUT ASIDE THEIR WEAVING AND TURNED TO OTHER THINGS.

**RESPECT THE POWER OF THE
SNAKE PEOPLE.**

WHEN MARY ROPER, THEN IN HER THIRTIES, TOLD THIS
STORY, SHE REINFORCED OUR BELIEF THAT QUINTESSENTIAL
NAVAJO THOUGHT SOMEHOW TRANSMITS FROM THE OLDER GEN-
ERATION OF TRADITIONAL WEAVERS TO THE YOUNGER WEAVERS
MORE IN TUNE WITH TODAY'S MEDIA-FOCUSED WORLD. MARY
TOLD US SHE HAD RECENTLY WOVEN A RUG, WHICH SHE SHOWED
TO HER AUNT, WHO, LIKE MARY'S MOTHER, GRANDMOTHER, AND
GREAT-GRANDMOTHER, IS A TRADITIONAL WEAVER. "YOU'VE
WOVEN SNAKES," HER AUNT DECLARED, REMINDED OF FIGURES
USED IN CEREMONIES AND SAND PAINTINGS. "I HAD NO INTEN-
TION OF DOING THAT, THOUGH," MARY REPORTED. AFTER DESCRIB-
ING THAT INCIDENT, SHE WAS SHOWN A PHOTOGRAPH OF THIS
SERAPE. "THAT'S IT. THAT'S THE DESIGN I WOVE," SHE EXCLAIMED,
"EXCEPT THAT I DID NOT PUT HEADS ON THE SNAKES."

ELDERS NELLIE AND WILLIE BECENTI CONFIRMED THAT
THESE FIGURES WERE INDEED SNAKES. BOTH ACKNOWLEDGED THE
POWER OF THE FIGURE, WHICH COMES FROM THE MALE
SHOOTINGWAY CEREMONY AND WORKS LIKE LIGHTNING FROM
THE SKY. IN THE COMPLEX NAVAJO NETWORK OF INTERLOCKING
SYMBOLS AND IDEAS, THE SNAKE IS ALSO ASSOCIATED WITH THE
WINDWAY CEREMONY. NELLIE AND WILLIE SPOKE OF THE SNAKE
WITH REVERENCE AND RESTRAINT; OTHER WEAVERS WHO SAW
THIS PIECE CONFIRMED THAT THE FIGURES WERE SNAKES AND
IDENTIFIED THE CENTRAL ONE AS MALE. THEY, TOO, ASSOCIATED
THIS PIECE WITH THE MALE SHOOTINGWAY AND WINDWAY CERE-
MONIES, ADDING THAT AS A CEREMONIAL BLANKET IT COULD BE
USED BOTH FOR EXORCISM AND SUMMONING BLESSINGS FROM
THE HOLY PEOPLE.

SOMETHING MAY HAVE BEEN TRANSMITTED TO MARY
ROPER, EVEN THOUGH SHE PARTICIPATES IN A MODERN WORLD
THAT SEEMS SO DIFFERENT FROM THE TRADITIONAL ELDERS'
WORLD. AS WE LOOKED AT THE OLDER MUSEUM *DAH'IISTŁ'Ó* AND
LISTENED TO WHAT THE ELDERS HAD TO SAY ABOUT THEM, WE
LEARNED TO RECOGNIZE A CERTAIN RESONANCE IN CONTEMPO-
RARY RUGS WOVEN BY YOUNGER WEAVERS.

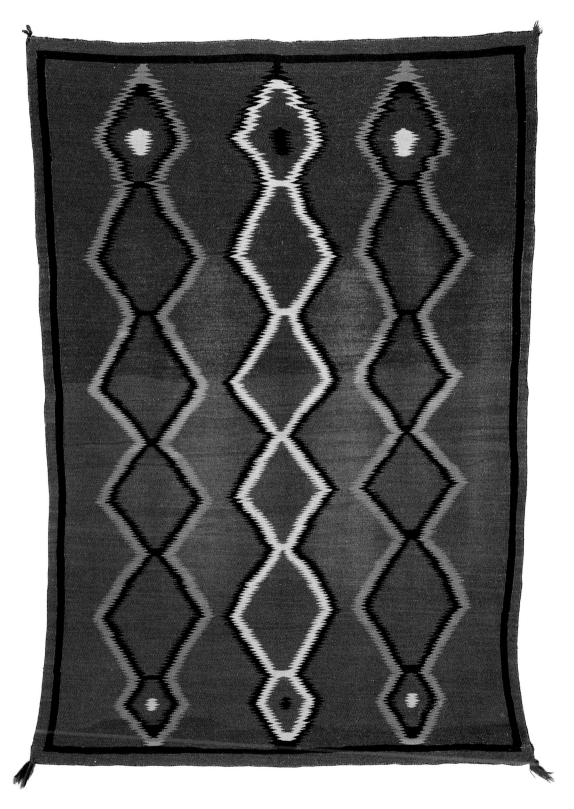

11

LATE CLASSIC SERAPE

1875-90, 53" x 73"

KNOWLEDGE AND THE POWER OF PRAYER CAN BE CONVEYED BY THE BIG STAR.

"I COULD TEACH YOU A LOT OF THINGS FROM THIS RUG," OBSERVED ELDER BILLY MARTIN WHEN HE FIRST SAW A PHOTOGRAPH OF IT. "IT CONTAINS POWERFUL PRAYERS THAT POP OUT OF THE EARTH AND INTO THE SKY. PRAYERS FOR MOTHER EARTH AND FATHER SKY. PRAYERS THAT HAVE TO DO WITH THE TWINS."

PRACTICALLY EVERYONE ELSE WHO SAW THIS RUG ASSOCIATED IT WITH A CEREMONY CALLED BIG STARWAY. MEDICINE MAN ERNEST BECENTI IMMEDIATELY RECOGNIZED THE EVENING STAR AT DUSK.

THIS PIECE AFFORDED OTHER ASSOCIATIONS AS WELL. THE SERRATED CORNERS WERE LINKED WITH RAIN, WITH EVENING LIGHT, WITH PATTERNS ON OLD ANASAZI POTSHERDS, AND ESPECIALLY WITH THE JOURNEY OF THE TWINS, WHO EVIDENTLY CONJOIN IN THE BIG STARWAY CEREMONY.

ELDERS WHO LOOKED AT THIS RUG AGREED THAT THE WEFT WAS WOVEN ON A COTTON WARP FROM THE TOP AND THE BOTTOM TOWARD THE MIDDLE—NOT AN ORDINARY PROCEDURE. USING A MICROSCOPE, VIEWERS SAW PARTICLES WOVEN INTO ALL FOUR CORNERS AND THE VERY CENTER OF THE STAR. GIVEN THE PATTERN OF WORN-OUT AREAS, HARRY BURNSIDE SPECULATED ON ITS USE AS A SADDLE BLANKET. "BUT NOT FOR SHEEPHERDING," ADDED JOE JOHNSON. "THE RIDER HAD SOME OTHER PURPOSE IN MIND." BY THEN THE ELDERS BEGAN BACKING AWAY FROM THE RUG ONE BY ONE, SEATING THEMSELVES AS FAR AWAY AS THEY COULD IN THE EXAMINATION AREA AND SPEAKING SOFTLY AMONG THEMSELVES. "IT POSSESSES A LOT OF POWER," EXPLAINED INTERPRETER BONNIE BENALLY, "AND THEY FEEL THEY MUST BE CAREFUL IN SPEAKING OF IT SINCE SPRING IS NOW HERE AND CERTAIN THINGS CANNOT BE SAID WITHOUT PROPER AUTHORIZATION."

FROM BIG STAR, KNOWLEDGE OF SOMEONE ELSE'S COMINGS AND GOINGS CAN BE EXTRAPOLATED. ONE STAR WATCHES OVER YOU, KNOWS EVERYTHING ABOUT YOU. IT CAN BE INVOKED IN A POWERFUL CEREMONY THAT HAS TO DO WITH STARGAZING, MIND READING, OR SOME OTHER PURPOSEFUL ACTIVITY. IT HAS SOMETHING TO DO WITH CASTING A SPELL. WRITE ABOUT THIS ITEM IF YOU LIKE, THE ELDERS AGREED, IF ONLY TO SAY THAT MANY OF THE OLD RUGS BEAR THE POWER OF THE CEREMONIES THEMSELVES.

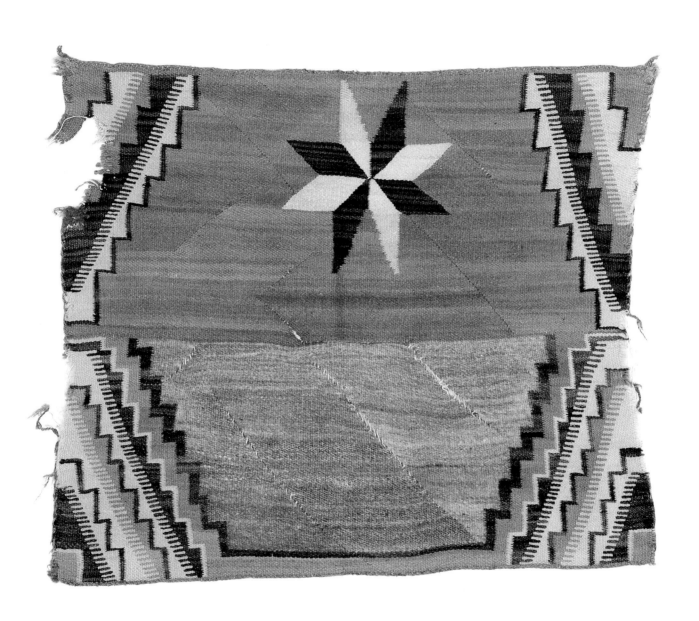

12
CATALOGED AS A SADDLE BLANKET
(PROBABLY USED CEREMONIALLY)

LATE 1800S, 33" x 28"

THE RESOURCEFUL HORNY TOAD ASSISTS MOTHER AND CHILD AS A BIRTH OCCURS.

THE FIGURE IN THIS RUG EXEMPLIFIES HOW THE ELDERS' WORDS CAN TURN AN ABSTRACT DESIGN INTO A CONCRETE IMAGE AMPLIFIED BY STORY AND SONG. HEARING FROM WEAVER AFTER WEAVER THAT EVERY DETAIL IN AN OLD RUG PRODUCED FOR HOME USE HAS A PURPOSE, WE INQUIRED ABOUT THE YELLOW ELEMENTS AND THEIR EMPLACEMENTS. FROM ALL CAME THE SAME REPLY: THIS WAS A MIDWIFE'S BLANKET, AND POLLEN AND CORNMEAL FACILITATE AN EASY BIRTH.

A HORNY TOAD'S RESOURCEFULNESS IS CELEBRATED IN MANY NAVAJO STORIES, AND ITS EASE IN LAYING EGGS AND THEN HOPPING AWAY IS WELL KNOWN. IN PREPARATION FOR A DELIVERY, A MIDWIFE WOULD CATCH A HORNY TOAD AND DEPOSIT POLLEN OR YELLOW CORNMEAL ON THE CREATURE'S HEAD, TAIL, AND TORSO AND FORCE SOME INTO ITS MOUTH BEFORE LETTING IT HOP AWAY. COLLECTING ANY CORNMEAL AND POLLEN THE CREATURE SPIT OUT AND GATHERING THAT WHICH FELL FROM ITS BACK, HEAD, AND TAIL, SHE WOULD PLACE THE MIXTURE IN HER MEDICINE BUNDLE. THE MIDWIFE WOULD THEN ADMINISTER THE COMPOUND AT BIRTHING TIME TO ASSURE THE EASY DELIVERY OF A CHILD WHO WOULD GROW UP HEALTHY AND ABLE. IF A MEDICINE MAN WERE NOT AVAILABLE, THE MIDWIFE MIGHT SING THE APPROPRIATE BLESSINGWAY SONGS HERSELF.

ASKED IF ANY WOMEN STILL FOLLOW THAT OLD PROCEDURE, ONE WEAVER REPLIED, "OH, NO. WE HAVEN'T HAD TO DO THAT EVER SINCE THEY BUILT THE HOSPITAL. THAT'S EVEN SAFER." NEVERTHELESS, PREGNANCY STILL CALLS FOR AN APPROPRIATE BLESSINGWAY CEREMONY, AND TRADITIONAL MOTHERS AND GRANDMOTHERS TEACH CHILDREN TO FIND A HORNY TOAD, PICK IT UP CAREFULLY, CLASP IT GENTLY TO HIS OR HER CHEST TO ABSORB ITS STRENGTH AND CAPABILITY, AND THEN RELEASE IT. MEANWHILE, STORIES ABOUT *NA'ASHǪ'II DISCH'ÍZHII,* THE HORNY TOAD, REMAIN POPULAR GUIDEPOSTS FOR YOUNG AND OLD ALIKE.

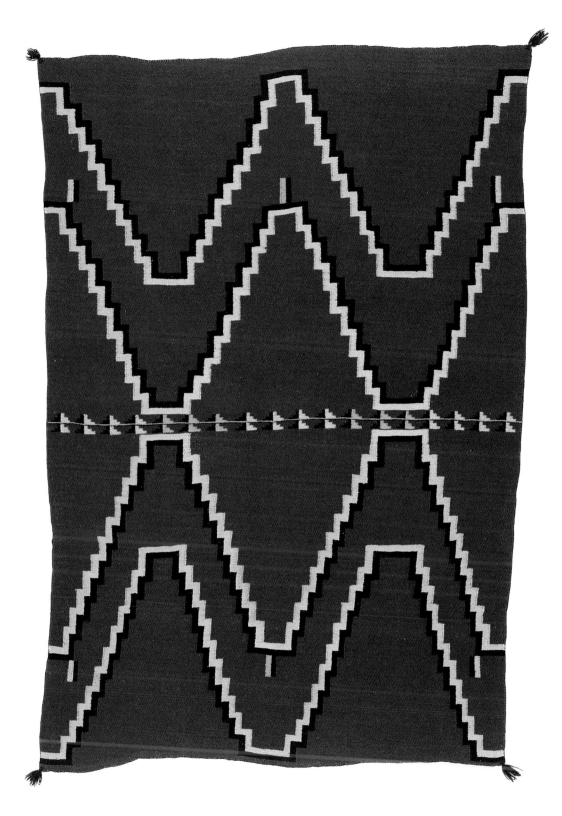

13

LATE CLASSIC CEREMONIAL SERAPE

CA. 1860S, 51" x 72"

A CHILD'S ENTRY INTO THE WORLD CELEBRATES THE BIRTH OF THE WARRIOR TWINS.

SOME WEAVERS HAVE IDENTIFIED THIS PIECE AS A MIDWIFE'S BLANKET. THE PARALLEL ZIGZAGS REPRESENT WOMEN'S SASH BELTS. THEIR DESIGN CONJURES UP THE *TL'ÓÓŁ NÁÁT'Í*, A ROPE DRAWN ACROSS A HOGAN'S MAIN CROSS BEAM, WHICH A MOTHER GRASPS AND PULLS AS SHE RELEASES A CHILD. A *TL'ÓÓŁ NÁÁT'Í* IS ALSO CALLED *SISŁICHÍ'Í*, OR RED BELT, ALONG WITH OTHER NAMES THAT REFER TO THE STRENGTH IT GIVES THE BIRTH MOTHER OR TO HOW SHE GRIPS IT. AS LORETTA BENALLY ONCE TOLD ANTHROPOLOGIST JOANNE MCCLOSKEY, "WHEN THE WOMAN IS IN LABOR AND SHE HOLDS ONTO IT, SHE IS ACTUALLY HOLDING ONTO THE RAINBOW."

INCLUDED IN MANY VERSIONS OF THE NAVAJO CREATION STORY IS A DESCRIPTION OF HOW THE SISTER DEITIES *ASDŹÁÁ NÁDLEECHÉ*, THE CHANGING WOMAN, AND *YOOŁGAI ASDŹÁÁ*, THE WHITE SHELL WOMAN, GIVE BIRTH SIMULTANEOUSLY TO *NAAYÉÉ NEIZGHÁNÍ*, THE MONSTER SLAYER, AND *TÓBÁJÍSHCHÍNÍ*, BORN FOR WATER, ASSISTED BY DRAGROPES GIVEN THEM BY THEIR SUPERNATURAL GRANDPARENTS, *HAASCH'ÉÉŁTI'Í*, THE TALKING GOD, AND *HAASHCH'ÉGHAAN*, THE GROWLING GOD. SIMILAR DESIGNS ARE COMMON IN SASH BELTS WOVEN AS SUCH AND CAN BE SEEN EMBEDDED IN COMMERCIAL RUGS WOVEN TODAY BY YOUNGER WEAVERS.

MARIE TEASYATWHO ASSOCIATED STRIPED BARS IN THE BACKGROUND WITH ALL THE CHILDREN THE MIDWIFE HAS BROUGHT OR WILL BRING INTO THE WORLD, AND WITH RAIN, THE TWO BEING NOT MUTUALLY EXCLUSIVE. NO TWO CHILDREN ARE EXACTLY ALIKE; NAVAJO WOMEN POINT OUT THAT EACH CHILD ASSUMES ITS OWN INDIVIDUAL CHARACTER AND BECOMES A UNIQUE PERSON. PIECES SUCH AS THIS ONE SERVE AS A REMINDER THAT WHEN A WOMAN GIVES BIRTH SHE TAKES HER PLACE IN THE BROAD SCHEME SET FORTH IN THE CREATION STORIES. SHE SHARES AN IDENTITY WITH ONE OR MORE OF THE HOLY PEOPLE. THE ARRIVAL OF THE NEWBORN CHILD CELEBRATES MANY THINGS: THE UNION OF FIRST WOMAN, *AŁTSE ASDŹÁÁ*, AND FIRST MAN, *AŁTSÉ HASTIIN*; THE BIRTH OF CHANGING WOMAN AND HER SISTER WHITE SHELL WOMAN; THE BIRTH OF THE TWINS; AND THE BIRTH OF THE *NI'HOOKÁÁ DINE'É*, THE FIVE-FINGERED EARTH SURFACE PEOPLE, FROM THE FLESH OF CHANGING WOMAN AND WHITE SHELL WOMAN.

> "SAYING NOTHING, *HAASCH'ÉÉŁTI'Í*, THE TALKING GOD, GAVE *ASDŹÁÁ NÁDLEEHÉ*, THE CHANGING WOMAN, ONE END OF THE STRAND OF SUNBEAM AND MOTIONED TO HER TO PULL IT WITH EACH SPASM OF PAIN SHE FELT. LIKEWISE SAYING NOTHING, *TÓ NEINILÍ*, THE RAIN GOD, GAVE ONE END OF THE STRAND OF RAINBOW TO *YOOŁGAI ASDŹÁÁ*, WHITE SHELL WOMAN, AND SILENTLY BID HER TO PULL IT WITH EACH SPASM OF LABOR SHE WAS TO FEEL. WHICH IS HOW IT CAME TO PASS THAT NAVAJO WOMEN WHO WALK THE SURFACE OF THIS WORLD TO THIS DAY PULL UPON A DRAGROPE WHENEVER THEY DELIVER NEW LIFE."
>
> *DINÉ BAHANE' : THE NAVAJO CREATION STORY*

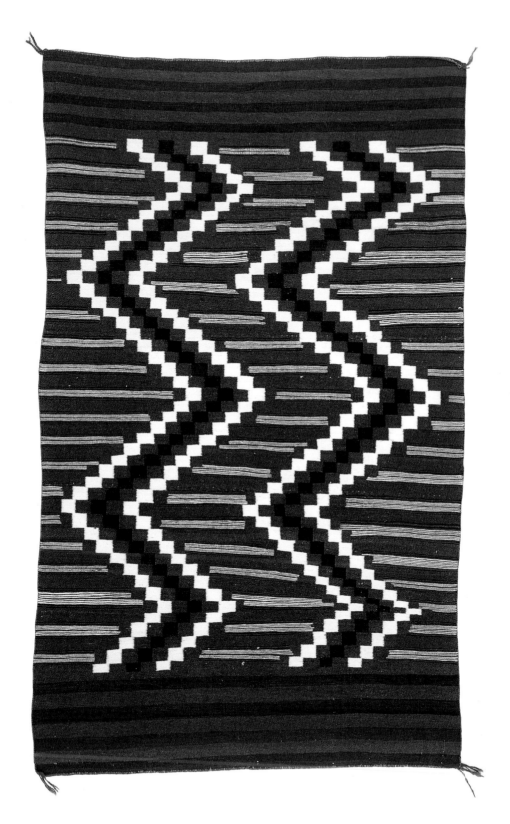

14

WEARING BLANKET

1860, 47"x75"

THE HOLY PEOPLE ARE SUMMONED FROM ABOVE AND BELOW.

UNTIL NOW, SMALL PIECES SUCH AS THIS HAVE BEEN CLASSIFIED AS MANTAS (SHAWLS) OR CHILDREN'S BLANKETS. THE ELDERS REPORT, HOWEVER, THAT MANY ARE CEREMONIAL ITEMS USED MUCH THE WAY SAND PAINTINGS ARE USED. THIS PIECE IS SAID TO BELONG TO THE MALE SHOOTINGWAY CEREMONY. IN THAT CEREMONY'S STORY, TWIN BROTHERS RESEMBLING THE WARRIOR TWINS UNDERTAKE A SERIES OF HAZARDOUS ADVENTURES. HEEDLESS OF THE DANGER THAT AWAITS THEM, THEY ENCOUNTER BUFFALO PEOPLE, BEAR PEOPLE, PORCUPINES, AND SNAKES; UNDERGO THREATENING METAMORPHOSES; AND VENTURE IN ALL FOUR DIRECTIONS, AS WELL AS HIGH ABOVE THE EARTH AND DEEP WITHIN IT. ONE OF THE TWINS IS TRANSFORMED INTO A COYOTE HIGH IN THE SKY; THE OTHER IS SWALLOWED BY A GIANT FISH AND TAKEN DEEP INTO THE EARTH'S WATERY REALM. BOTH MUST BE RESCUED BY THE *DIYIN DINE'É,* THE HOLY PEOPLE, WHO TEACH THEM HOW TO CURE THE AFFLICTIONS RESULTING FROM THEIR FOOLHARDINESS.

ONE GROUP OF VISITORS ASSOCIATED THE ZIGZAGS IN THIS PIECE WITH SKYWARD THUNDERCLOUDS, LIGHTNING, AND TORRENTIAL RAINFALL. THE WHITE CROSSES, THEY ADDED, SIGNIFIED *TSIN NÁÁBAAŁÍ JINÍ,* OR WHIRLING LOGS, DEEP WITHIN THE EARTH, SIMILAR TO THOSE SEEN IN PLATE 22.

THE HOLY PEOPLE EXIST EVERYWHERE ABOVE AND WITHIN, AND THEY CAN DIRECT THEIR ENERGY FROM THE DEEP OR FROM ON HIGH. THAT OMNIPRESENCE IS DESCRIBED IN STORIES THAT RECOUNT CREATION OR COMPRISE THE MALE SHOOTINGWAY CEREMONY. THE ENERGY IS INVOKED WHENEVER A CEREMONIAL PATIENT SITS OR STEPS UPON A SAND PAINTING OR CEREMONIAL *DAH'IISTŁʼǪ* SUCH AS THIS ONE, AND IT IS ACTIVATED WITH SONG AND INTENSIFIED WHEN LYRICS ARE REPEATED THROUGHOUT THE NIGHT IN A POETIC STYLE THAT MATCHES THE VISUAL STYLE EVIDENT IN THE DESIGNS.

WHAT LOOKS LIKE SLAVISH REPETITION IN THIS PIECE IS REALLY CALCULATED CONTRAST. TWO WHITE CROSSES IN THE MEDIAL ZONE BREAK WHAT WOULD OTHERWISE BE TWO VERTICAL ROWS. THREE DARK CROSSES IN THE SAME ZONE OFFSET THE SINGLE CROSSES IN EACH OF THE TWO OUTER HORIZONTAL ROWS. HEARD ATTENTIVELY, SONGS DISPLAY THE SAME SUBTLE PROGRESSION IN THE WAY THEY VOICE AN APPEAL TO THE HOLY PEOPLE. VERBAL AND VISUAL BALANCE AND COUNTERPOISE FORM A DYNAMIC UNITY THAT UNDERLIES ALL ART. LIKE WEAVING, PRAYER IS A SUBTLE ACT, REQUIRING DELIBERATE EXPRESSION AND CAREFUL ATTENTION.

ON ONE SIDE OF THIS TEXTILE WE FOUND A FRAMELIKE CONFIGURATION. UPON MAGNIFICATION, WE FOUND INSIDE IT TWO ELONGATED OBJECTS. ONE IS BLUE, THE OTHER IS WHITE; ONE POINTS NORTH, THE OTHER POINTS SOUTH. LOOKING AT THE OBJECTS WITH A MICROSCOPE, WEAVER NANCY PINTO THOUGHT THEY WERE FROM THE INSIDE OF A WATERMELON SEED. HARRY AND ANNIE BURNSIDE CONJECTURED THAT THEY WERE SOME KIND OF PLANT FIBER. WHEN LORETTA BENALLY LOOKED, SHE SAID THE ARRAY RESEMBLED A HEAD AND "COULD BE A *YE'II,*" IS THE GENERAL TERM FOR DEITY.

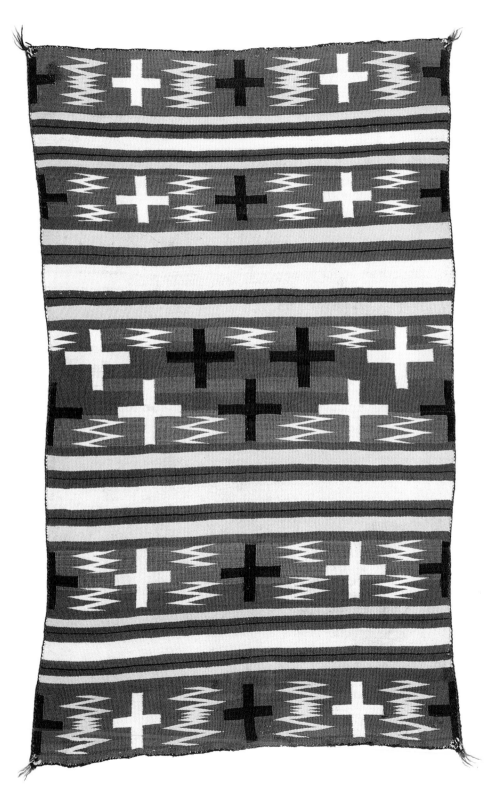

15

CLASSIFIED AS A LATE CLASSIC SERAPE

(PROBABLY A CEREMONIAL BLANKET)

1870-80, 29" x 48"

WEAVING A DIYOGÍ IS ITS OWN
CEREMONY. THE PRAYERS ARE WORKING.

NOTICE IN THIS SADDLE BLANKET THE DEGREE OF VARIA-
TION, RANGING FROM THE MANIFEST TO THE VERY SUBTLE. THE
SAME KIND OF SLIGHT BUT INTENSE VARIATION CAN BE HEARD IN
ANY OF THE MANY SONGS THAT MAKE UP A CEREMONY. IN THESE
SONGS A SEEMINGLY REPEATED LINE MAY VARY BY ONE OR MORE
SYLLABLES, ALLOWING THE SONG'S MEANING TO PROGRESS. LOOK
CLOSELY, TOO, FOR DEFT TRANSITIONS SUCH AS THOSE THAT OFF-
SET ONE VERTICAL ROW AGAINST AN ADJOINING ONE.

WEAVERS WHO EXAMINED THIS PIECE RECOGNIZED A CON-
CENTRATION IN IT TO THE POINT OF DEVOTION. AS SHE ADMIRED
THIS SPECIMEN, JUNE KALLECO SMILED
BROADLY AND THEN EXPLAINED HOW
SHE STARTS EACH RUG WITH A
PRAYER, MUCH AS A TRADITIONAL
NAVAJO WOULD BEGIN EACH DAY. AS
SHE CONTINUES TO PRAY, HER WORK
GETS BETTER AND SHE CAN ENTER
INTO IT. BY THE TIME SHE REACHES THE MIDDLE, SHE IS WEAVING
AT HER BEST—AT A KIND OF HIGH NOON, OR ZENITH, OF PERFECT-
ED PROCESS. THE PRAYERS ARE WORKING. THEN SHE REVERSES
HERSELF CONFIDENTLY AND LETS HERSELF OUT AGAIN. INSISTING
THAT EACH WEAVING REPRESENTS A SINGLE DAY'S SPAN OF SUN-
LIGHT FROM DAWN TO DUSK, ELDER RAYMOND JIM ALIGNED THE
MEDIAL STRIP WITH THE SUN'S HIGHEST POINT IN THE SKY.
"WHILE RELUCTANT TO HAVE HER WORDS OVERHEARD," HE SAID,
"A TRADITIONAL WEAVER BEGINS EACH RUG WITH A PRAYER TO
THE DAWN AND ENDS BY OFFERING HER WORK TO *NA'ASHJÉ'II
ASDZ̨Ą́Á́*, THE SPIDER WOMAN, IN GRATITUDE FOR THE WEALTH IT
WILL BRING." TRADITIONALLY, A CHILD BEING TAUGHT TO WEAVE
WOULD LEARN A SERIES OF SPECIAL SONG-PRAYERS ALLEGEDLY
PASSED DOWN TO THE PEOPLE FROM SPIDER WOMAN. INDEED,
SOME WEAVERS CONFIRMED THAT A WEAVING SUCH AS THIS ONE
CONTAINS VISUALLY DISCERNIBLE ELEMENTS THAT ARE ANALO-
GOUS TO AUDIBLE STRUCTURAL ELEMENTS REVEALED WHEN
PRAYERS ARE RECITED IN THE *BLESSINGWAY* AND IN HEALING
CEREMONIES.

OF ORIGINS
 I HAVE FULL KNOWLEDGE.
OF EARTH'S ORIGIN
 I HAVE FULL KNOWLEDGE.
OF PLANT ORIGINS
 I HAVE FULL KNOWLEDGE.
OF VARIOUS FABRICS' ORIGINS
 I HAVE FULL KNOWLEDGE.
NOW OF LONG LIFE'S ORIGINS
 I HAVE FULL KNOWLEDGE.
NOW OF HAPPINESS'S ORIGIN
 I HAVE FULL KNOWLEDGE.

*A typical weaving song designed to trans-
form the weaver's thoughts into something
tangible.*

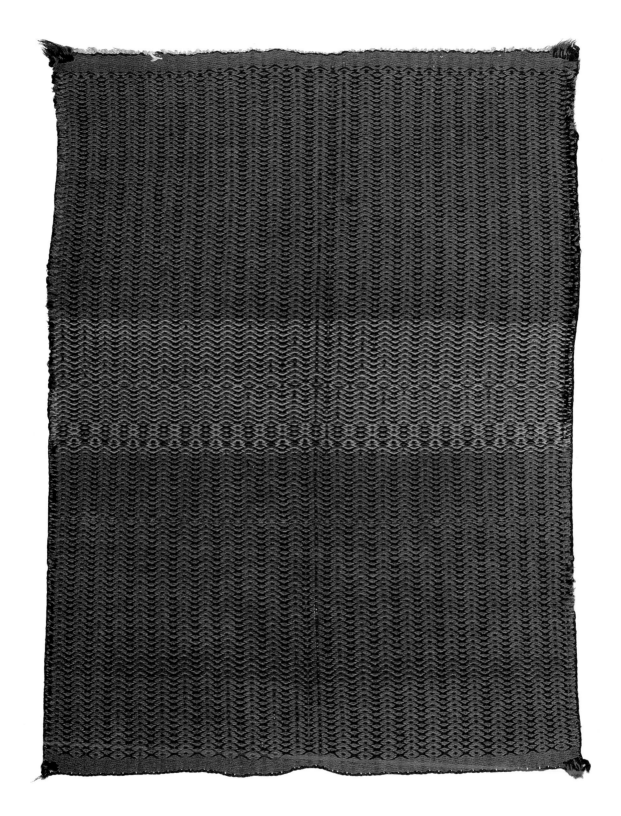

16

DOUBLE-WEAVE SADDLE BLANKET

1910, 24"x37"

IV. Harmony and Disharmony:

Keeping the World in Balance

HÓZHǪ IS HARD WON, ACCORDING TO THE ANCIENT STORIES. IN ONE KEY EPISODE, *AŁTSÉ HASTIIN*, THE FIRST MAN, NOTICES A DARK CLOUD ON *CH'ÓOL'Į*, THE GIANT SPRUCE MOUNTAIN. IT IS A DESPERATE TIME WHEN ONLY A HANDFUL OF SURVIVORS REMAIN AS THE *NAAYÉÉ*, THE DEVOURING MONSTERS, PERSIST UNOPPOSED IN THEIR RAVENOUS WAYS. AWARE OF THE RISK, THE FIRST MAN RESOLVES TO GO TO THE GIANT SPRUCE MOUNTAIN TO INVESTIGATE. HE SURROUNDS HIMSELF WITH SONG AS HE LABORS TO THE SUMMIT ON BEHALF OF THOSE WHO ARE TO OCCUPY THE EARTH, PURSUING THE IDEALS OF LONG LIFE AND HAPPINESS—THE END RESULT OF THE HARMONY HE SEEKS THROUGH SONG.

EARNING *HÓZHǪ* IS NOT ENOUGH, HOWEVER. IT MUST BE SAFEGUARDED. SOMETIMES *HÓZHǪ* CAN BE RETAINED ONLY WITH A STRUGGLE; WHEN LOST, IT IS RESTORED WITH AN EVEN GREATER STRUGGLE. OFTEN THE MEANDERING WAYS OF *MA'II*, THE COYOTE, NECESSITATE THAT STRUGGLE, AS WHEN HE MARRIES INTO A FAMILY THROUGH TRICKERY OR INTRUDES IN SOME OTHER DEVIOUS WAY. *HÓZHǪ* IS NECESSARY, TOO, WHEN CHANGE FROM WITHOUT PUTS A STRAIN ON THE COLLECTIVE MEMORY WITHIN. "IT IS TOO EASY FOR OUR YOUNG PEOPLE TO FORGET," THE ELDERS SAY. "WE MUST MAKE THE OLD WAYS AVAILABLE TO THEM HOWEVER WE CAN."

"SETTING PLANTS IN ROWS WILL NOT BE A GOOD THING," INSISTS COYOTE.

DRAMATIC CONTRAST OF COLOR, SHAPE, AND DESIGN CAN ALL BUT PREEMPT A DETAILED SCRUTINY OF A NAVAJO BLANKET OR RUG. SO STUNNING IS THE EFFECT, WE RESIST DETERMINING HOW IT OCCURS, ESPECIALLY WITHOUT KNOWLEDGE OF THE WEAVER'S TRADITION. THAT IS THE CASE IN THIS PIECE IN WHICH SMALL VARIATIONS AND IRREGULARITIES ARE OVERSHADOWED BY A LARGER ARRAY OF OPPOSITIONAL ELEMENTS: THE BLACK CONTRASTED WITH THE WHITE, THE TOP AND BOTTOM STRIPES OF MUTED RED AND GRAY POISED AGAINST THE BOLDER BLACK-WHITE OR RED-GRAY CONTRASTS, AND THE CENTRAL CURVATURE EMBRACED BY A BORDER OF SQUARES.

NOTE THE SOLID BLACK SQUARE ON ONLY ONE OF THE CORNERS. COUNT THE SPLIT SQUARES ON EACH OF THE VERTICAL EDGES AND THEN OBSERVE HOW THE NUMBER OF SERRATED POINTS WITHIN THE SQUARES REMAINS CONSTANT ALONG THE HORIZONTAL EDGES WHILE IT VARIES FROM ONE VERTICAL SIDE TO THE OTHER. THIS PIECE MAKES US THINK OF THE TRICKSTER *MA'II*, THE COYOTE, ALWAYS MOVING ALONG RESTLESSLY, WANTING TO MAKE SUDDEN CHANGES, UNWILLING TO ACCEPT PERFECT ORDER. STORIES ABOUT COYOTE ARE AN IMPORTANT COMPONENT IN THE EDUCATION OF CHILDREN IN TRADITIONAL NAVAJO HOUSEHOLDS FOR THEY ADD A PHILOSOPHICAL DIMENSION TO THE NAVAJO WAY OF SEEING AND BEHAVING.

WHEN ELDER JOHN BLACKWATER, FROM SWEETWATER, ARIZONA, SAW THIS RUG HE VOLUNTEERED THAT COYOTE FIGURES IN IT, AS HE DOES IN MANY OTHER RUGS. EVEN THE ARCHES STRADDLING THE CENTER INVOKE HIM WITH THEIR WIDE MEANDERING. WHEN COYOTE WAS ASKED HIS OPINION DURING THE SHAPING OF THE FIFTH WORLD ABOUT PLANTING CORN IN NEAT ROWS, HE SAID THIS IN HIS CHARACTERISTICALLY GARBLED WAY: "SETTING PLANTS IN ROWS, YOU CAN SEE, WILL NOT BE A GOOD THING, SINCE IF AT ANY TIME ONE OF THE PLANTS, OR LIKEWISE ONE OF THOSE THAT GIVE BIRTH, SHOULD DIE, THERE WOULD BE CONSPICUOUS GAPS AND PASSAGEWAYS BETWEEN THEM. . . . MAKE IT SO THAT THEY EXIST EVERYWHERE ON EARTH'S SURFACE WITHOUT ANY SPECIAL ORDER." REAL HARMONY OCCURS ONLY WHEN BALANCE IS NOT ARTIFICIAL.

WE MUST BEAR IN MIND THAT THIS TEXTILE ISSUES FROM A DEEPLY EMBEDDED NAVAJO PERSPECTIVE, WHETHER CONSCIOUSLY APPLIED OR NOT. "REMEMBER," JOHN BLACKWATER CAUTIONED, "THE WEAVER MIGHT NOT HAVE SOME SPECIFIC INTENT IN MIND. BECAUSE THEY KNOW THE PRAYERS AND KNOW THE SONGS, THOUGH, WEAVERS DON'T HAVE TO POSSESS INTENTIONALITY. IT JUST COMES. IT COMES FROM KNOWING THE STORIES AND SONGS."

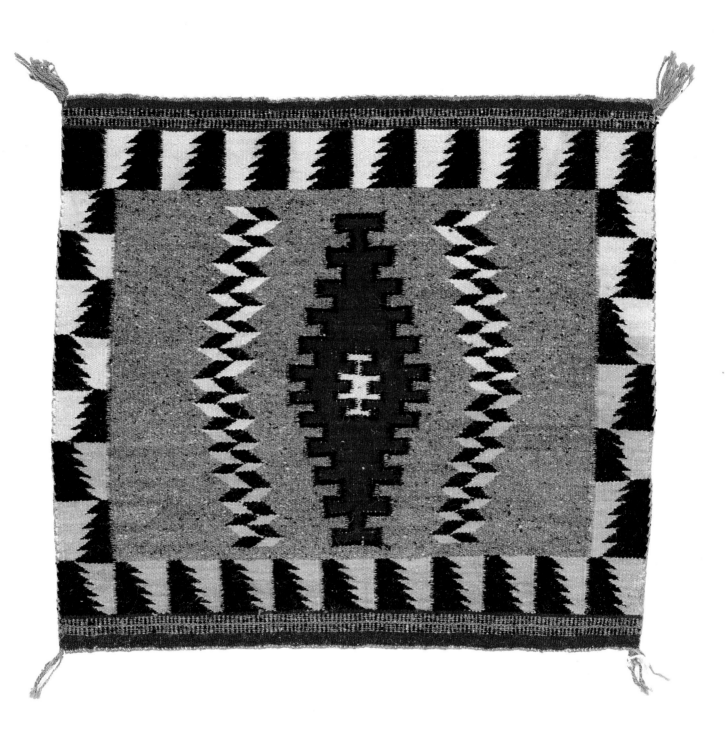

17

CATALOGED AS A SADDLE BLANKET

(PROBABLY CEREMONIAL)

N.D., 25" x 22"

"EVERYWHERE YOU GO, YOU BRING DISORDER," COYOTE IS TOLD.

TO NAVAJOS, CELESTIAL SPACE CONTAINS BOTH ORDER AND DISORDER, AND IT IS FULL OF MYSTERY AND SACRED KNOWLEDGE, WHICH IS SOMETIMES ESOTERIC AND SOMETIMES WIDELY SHARED. IT TELLS WHEN TO PLANT, HARVEST, AND HUNT; WHEN STORY-TELLING SEASON BEGINS AND ENDS; WHEN SNAKES AND SPIDERS ARE AT REST; AND WHEN CEREMONIES MAY OR MAY NOT OCCUR.

INDICATING THAT THE MOON AND STARS ARE REPRESENTED IN THIS PIECE, ETTA CHAVEZ STRESSED THE LUNAR CRESCENTS' IMPORTANCE WITHOUT SPECIFYING FURTHER. "THOSE REPRESENTED HERE," ADDED MINNIE BECENTI, "HAVE CALENDRICAL SIGNIFI-CANCE." THIS PIECE MAY RELATE TO THE MIGHTY NIGHTWAY CERE-MONY, WHICH TELLS TWO SEPARATE STORIES WHEREIN HEROES ARE REJECTED BY THEIR RESPECTIVE FAMILIES, MANAGE TO OVER-COME DANGERS WITH HELP FROM THE HOLY PEOPLE, RETURN TO THEIR FAMILIES TO TELL THEIR TALES, AND SHARE WITH THEIR ERSTWHILE TORMENTORS KNOWLEDGE NEEDED TO RESTORE BAL-ANCE. IN ONE VERSION, THE VISIONARY HERO'S CONFUSION INTENSIFIES WHEN HE FOLLOWS MA'II, THE COYOTE, INTO THE SKY.

IN WHAT MAY BE A RELATED PIECE, ELDERS SAW IN FIGURE 8 ON PAGE 24 COYOTE'S IMPATIENCE AS *AŁTSÉ HASTIIN*, THE FIRST MAN, TRIES TO OFFSET DARKNESS BY DECORATING THE NIGHT SKY WITH STARS. WORKING METHODICALLY THROUGHOUT THE NIGHT, FIRST MAN TAKES CHIPS OF MICA GATHERED ON A BLANKET AND PLACES THEM ONE BY ONE OVERHEAD IN THE SKY, BUT COYOTE GRABS THE BLANKET IN HIS FOREPAWS AND SHAKES IT UPWARD WILLY-NILLY, CREATING DISORDER.

THE VARIATION OF STARS FROM ROW TO ROW IN THIS *DIYO-GÍ* HELPS TO EXPLAIN THE INTERPLAY IN THIS PIECE AND IN OTH-ERS BETWEEN BROAD FEATURES OF SYMMETRY AND NARROW DETAILS OF CONTRAST. IN AN OTHERWISE HOMOLOGOUS OR SYM-METRICAL FIELD, NOTICE HOW THE INNER ROW OF CRESCENTS INCLUDES ONLY GREEN ON THE BOTTOM HALF, WHILE IN ITS COR-RESPONDING ROW ON THE TOP HALF, THE CRESCENTS ALTERNATE GREEN-WHITE-GREEN-WHITE-GREEN. LIKEWISE, THE THICK, BLUE STRIPE ABOVE THE ALL-GREEN ROW OF CRESCENTS BEARS A NAR-ROW STRIP OF GREEN AT EACH WEFT EDGE, WHILE ITS COUNTER-PART DOES NOT. MORE OBVIOUS, OF COURSE, IS THE PINK CON-NECTING THE TWO INNER CROSSES, TRADITIONALLY RELATED TO LIGHTNING AND THE USE AND MISUSE OF ITS POWER BUT MORE RECENTLY ASSOCIATED WITH ELECTRICITY. IN MUCH THE SAME WAY THAT THE HUMAN MALE AND HUMAN FEMALE ARE AT ONCE ALIKE AND DISSIMILAR, THE TWO HALVES OF THIS PIECE CREATE A DYNAMIC, PRODUCTIVE COUNTERPOISE. GO BEYOND THE INITIAL IMPRESSION OF SYMMETRY BY SEEING HOW MANY VERY SMALL DIFFERENCES FROM SIDE TO SIDE THIS PIECE CONTAINS. IT IS THAT WAY WITH MOST TRADITIONALLY WOVEN NAVAJO TEXTILES. COYOTE SOMETIMES ACHIEVES HIS GREATEST MISCHIEF BY CREAT-ING AN ILLUSION OF NORMALITY THAT MUST BE PENETRATED WITH CAREFUL OBSERVATION.

"EVERYWHERE YOU GO, YOU BRING DISORDER," ONE GROUP OF AIR SPIRIT PEOPLE ADMONISHED COYOTE IN REFUSING TO ALLOW HIM TO JOIN THEM. THEY ARE RIGHT, OF COURSE, BUT AS THEY STRUGGLE TO RESIST HIM OR UNDO HIS DAMAGE, THEY CAN MAINTAIN *HÓZHǪ*.

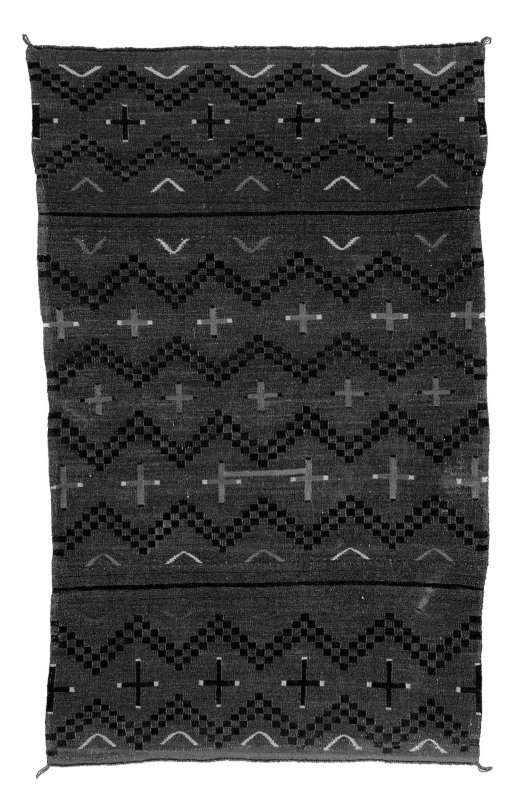

18

LATE CLASSIC WOOL SERAPE

1870-75, 34" x 53"

SEND WORD TO THE SPIDER PEOPLE TO
HELP STOP COYOTE'S DISORDERLY WAYS.

CONCEIVABLY MADE BY A WEAVER LIVING SOMEWHERE IN
CAPTIVITY, THIS TEXTILE DEMONSTRATES HOW SHAPES AND COL-
ORS CAN COMBINE AT THE LOOM TO UNITE STORY AND CEREMO-
NY. MASTER WEAVER LORETTA BENALLY HAS POINTED OUT THE
PROMINENCE OF SPIDERS ALIKE HERE AND IN PLATE 3, ALLOWING
FOR VARIATION IN COLOR AND DETAIL. "NOT ONLY DID THE SPIDER
PEOPLE TEACH THE NAVAJOS HOW TO WEAVE IN THE ANCIENT
TIME," SHE EXPLAINED, "THEY PROVIDED HELP AND PROTECTION
AND WERE OFTEN INSTRUMENTAL IN RESTORING THE HARMONY
SO OFTEN THREATENED BY MA'II, THE COYOTE."

SHE BEGAN A LONG INTERPRETATION OF THIS DIYOGÍ BY
CONFIRMING THAT FOUR CORNSTALKS EXTEND HORIZONTALLY
FROM THE CENTRAL DIAMOND TO THE BORDERING TRIANGLES ON
EACH EDGE OF THE BROAD MIDDLE ZONE. SHE THEN IDENTIFIED
THE BLACK-AND-BROWN TERRACES IN BOTH END ZONES AS MALE
RAIN CLOUDS, AND SHE CALLED THE TWO PAIRS OF WHITE STRIPES

BEYOND THE TERRACES "SUN DOGS," A TERM USED TO DESIGNATE
THE PLAY OF CLOUD AND SUNLIGHT WITH AFTERNOON RAINS THAT
NOURISH THE RIPENING CORN. DIFFERENT DEGREES OF PRECIPITA-
TION APPEAR IN THE CHEVRONS BORDERING THE MEDIAL ZONE,
INCLUDING THE GENTLER, STEADIER FEMALE RAIN AND THE MORE
SUDDEN AND FORCEFUL MALE RAIN. SHE CITED AN OLD CEREMO-
NY, THE CORNSTALK WAY, WHICH SHE ASSOCIATED WITH THIS
PIECE. IT TELLS HOW THE SPIDER PEOPLE ONCE CAPTURED COYOTE
AT A TIME WHEN HE WAS CAUSING GREAT DISHARMONY. SHE
ALIGNED THE FOUR RED STRIPES WHERE THE MIDDLE ZONE CON-
VERGED WITH THE FOUR TIERS OF WEBS THE SPIDER PEOPLE USED
TO TRAP HIM AND TOLD HOW HE MADE HIS WAY THROUGH THE
FIRST THREE WITH INCREASING DIFFICULTY AND WAS FULLY
CAUGHT BY THE FOURTH. BROADLY SPEAKING, THEN, THIS RUG
DEALS WITH THE WAY THE SPIDER PEOPLE HELP KEEP THE LIVES OF
OTHERS ON COURSE WITH WHAT THE EARTH YIELDS EACH GROW-
ING SEASON.

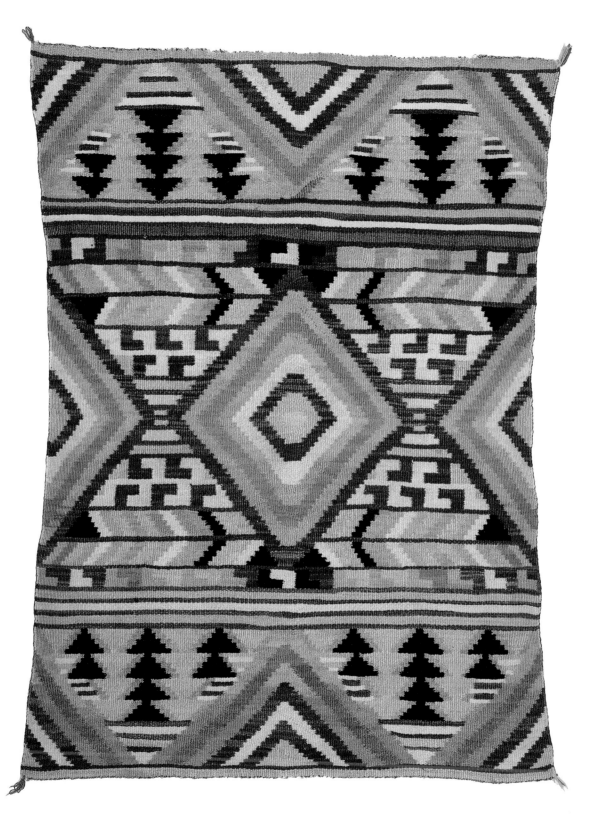

19

CATALOGED AS A "SLAVE BLANKET"

1880S, 48"x 64"

HEAVY WIND AND HARD RAIN PURGE THE
EARTH OF MONSTERS.

IN ONE EPISODE OF THE NAVAJO CREATION STORY, *ASDZ̨Ą́Ą́*
NÁDLEEHÉ, CHANGING WOMAN, BRINGS A VIOLENT STORM TO
PURGE THE EARTH OF ALL REMAINING MONSTERS AFTER THE
WARRIOR TWINS DEFEAT THE MOST DANGEROUS ONES. A FRENZY
OF HEAVY WIND, HARD RAIN, AND VIOLENT THUNDER BATTERS
THE LAND, UPROOTING TREES AND ERODING SOIL TO CREATE A
SPARSE LANDSCAPE OF CANYONS, DESERT, MESAS, AND MOUN-
TAINS. REMINDED OF THAT STORY AS SHE LOOKED AT A PHOTO-
GRAPH OF THIS RUG, MARY BIGGS SAID THAT THE ZIGZAG DESIGN
CONTAIN MUCH POWER. "WHEN THERE'S A SEVERE THUNDER-
STORM," SHE SAID, "SOMEBODY WILL WEAR A BLANKET LIKE THIS
AND PRAY TO THE RAIN PEOPLE TO MOVE THE STORM AWAY WHEN
IT BECOMES TOO SEVERE."

WHEN ELEANOR SANDOVAL SAW THIS PIECE DURING A
MUSEUM VISIT, SHE RECOGNIZED A SUNRISE IN THE BOTTOM RED
END ZONE, A SUNSET IN THE TOP RED ZONE, THE SPAN OF DAY-
LIGHT HOURS THROUGH THE SECTION IN BETWEEN, AND HIGH
NOON, SPECULATING THAT THE LIGHTER ZIGZAG ZONE REPRESENTS
MORNING THUNDERSTORMS, WHILE THE DARKER ONE DESIGNATES
AFTERNOON STORMS.

WOVEN INTO THIS BLANKET WHILE STILL GREEN AND SOFT
IS A PARTICLE OF PLANT MATTER. WE ALSO FOUND A STRAND OF
SINEW, ALSO DELIBERATELY INTERWOVEN BY THE WEAVER. MARY
BIGGS ASSOCIATES THE PLANT MATTER AND THE SINEW WITH
HEAVY PROTECTION, WHILE ELEANOR SPECULATED THAT THIS
DIYOGÍ WAS USED FOR HUNTING WHEN SHE SAW THE PARTICLES
THROUGH A MICROSCOPE. TO HER WAY OF THINKING, SUCH A
BLANKET MIGHT BE WORN WHEN HUNTING LARGE GAME, SUCH
AS DEER, ELK, AND ANTELOPE.

TO AN OUTSIDER WITH NO KNOWLEDGE OF THE INTRICATE
CEREMONIAL AND STORYTELLING TRADITION, A NAVAJO TEXTILE IS
A MUTE DESIGN. THOSE WHO WISH TO SEE MORE IN A RUG CAN
LEARN TO COMBINE COMMENTS SUCH AS THESE WITH DETAILED
OBSERVATION AND WITH WHAT THE STORIES SAY. A *DAH'IISTŁ'Ǫ́*
CAN BEAR MULTIPLE INTERPRETATIONS, AND CONTRADICTIONS
BETWEEN THEM CAN OCCUR. TO TRADITIONALLY REARED NAVAJOS,
THE RUGS ARE FULL OF MEANING DERIVED FROM STORIES HEARD,
CEREMONIES ATTENDED, AND FIRSTHAND INFORMATION OBTAINED
WITHIN THE FRAMEWORK OF A WORLDVIEW WIDELY SHARED BY
PEOPLE WHO MAINTAIN THEIR INDIVIDUAL PERSPECTIVES IN THE
CONTEXT OF A SHARED PAST.

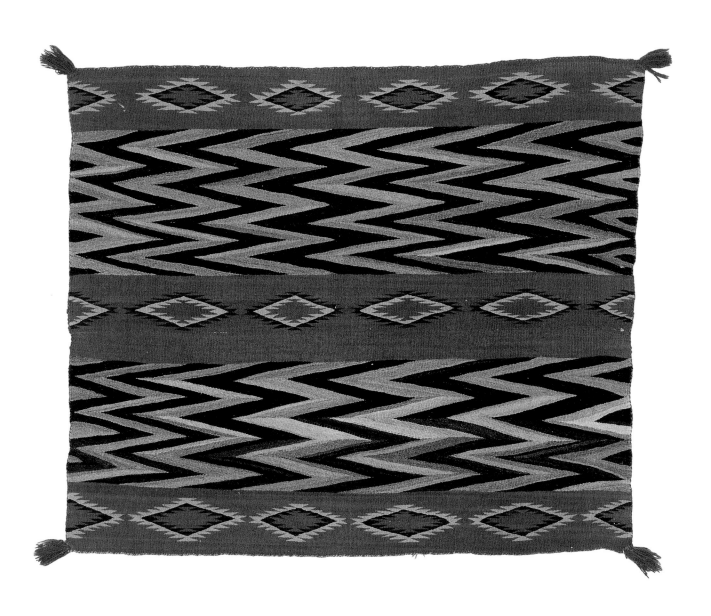

20

WOMAN'S SHOULDER BLANKET

1880-90, 51" x 43"

WITH FEATHERS AND POLLEN, YOU CAN
MEET ANY DANGER.

INTERVIEWED WITH HIS WEAVER WIFE ANNIE AT THEIR
HOME IN CROWNPOINT, NEW MEXICO, HARRY BURNSIDE POINTED
OUT THAT CERTAIN LARGE BLANKETS SUCH AS THIS ONE WERE
ALSO WORN FOR PROTECTION. "WHEN YOU WEAVE A BLANKET IN
A CERTAIN WAY, HARM CANNOT BEFALL YOU," HE SAID. "THERE
ARE THINGS THAT GO IN A RUG THAT ARE ALIGNED WITH
WILDLIFE. OBJECTS ARE WOVEN IN TO SEEK AN ALLIANCE WITH
CERTAIN CREATURES," HE WENT ON TO EXPLAIN, OFFERING A
NAVAJO PHRASE, WHICH WAS RENDERED IN ENGLISH AS, "THEY
[BIG ANIMALS SUCH AS BEARS AND COUGARS] WILL TURN AWAY
FROM YOU SO AS NOT TO DO YOU ANY HARM."

THIS UNUSUAL *DAH'IISTŁ'Ọ́* COULD BE SUCH A BLANKET.
ITS MOST COMPELLING FEATURE IS THE SMALL RECTANGULAR
AREA RESEMBLING A PATCH NEAR THE LEFT WEFT EDGE ALMOST
MIDWAY UP FROM THE BOTTOM. SPOTS SUCH AS THIS ONE ARE-
TYPICALLY MISTAKEN AS MENDS. ELICITING A GREAT DEAL OF
INTEREST AMONG THE ELDERS WHO EXAMINED IT, ALL AGREED
THAT THE PATCH WAS DELIBERATELY MADE, AND LORETTA BENALLY
SAID THAT THIS ONE WAS UNLIKE ANY SHE HAD EVER SEEN.

MAGNIFICATION REVEALED A VARIETY OF MINUTIAE: HAIRS
FROM A GOAT, A BOBCAT, AND A BEAR; SHAVINGS OF BEAR CLAW;
GRANULES OF CORN; AND RED FIBERS WHOSE SOURCE IS
UNKNOWN. EVER CAUTIOUS IN HIS SPECULATION, HARRY
BURNSIDE BELIEVED THAT THE SMALL PATCH MIGHT HAVE BEEN
USED TO DESIGNATE PRAYERS FOR PROTECTION. "THE WHOLE
PATCH SEEMS TO RESEMBLE A CORN POLLEN BAG IN SHAPE, COM-
PLETE WITH A FRINGE," OFFERED WILLIE BECENTI.

A MOST SACRED SUBSTANCE, POLLEN IS USED CEREMONI-
ALLY BOTH IN GROUPS AND PRIVATELY AS AN OFFERING TO THE
HOLY PEOPLE IN A GESTURE OF SUPPLICATION AND PROTECTION.
WITH ITS UNIQUE BUOYANCY, *HÓZHỌ́* MATERIALIZES IN IT. POLLEN
BEARS THE FORCE AND PERVASIVENESS OF SUNLIGHT AND OF
EACH INDIVIDUAL'S INDWELLING SPIRIT. IT REPRESENTS THE
POWER OF THE WIND AND THE PRESENCE OF AIR FOUND EVERY-
WHERE. IT CLEARS THE TRAIL SO A PERSON CAN PROCEED SAFELY,
MAKING A PATHWAY OF PROGRESS.

WHEN *NA'ASHJÉ'II ASDZ̧ÁÁ*, THE SPIDER WOMAN,
INSTRUCTED THE WARRIOR TWINS ON HOW TO FOLLOW *ATIIN
DIYINII*, THE HOLY TRAIL, TO THEIR FATHER *JÓHONAA'ÉÍ*, THE SUN,
SHE GAVE THEM A *NAAYÉÉ ATS'OS*, A SACRED HOOP MADE OF

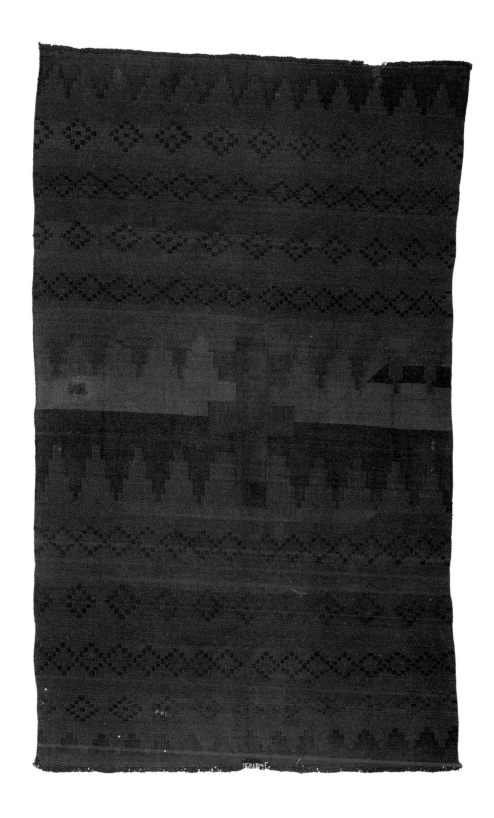

21

DOUBLE-WEAVE SADDLE BLANKET

N.D., 34" x 53"

EAGLE FEATHERS. "WHENEVER YOU FACE A DANGER," SHE INSTRUCTED THEM, "HOLD [THIS] *NAAYÉÉ ATS'OS* IN YOUR HAND AND EXTEND IT TOWARD WHATEVER THREATENS YOU." THEN SHE CONTINUED WITH AN INSTRUCTION THAT ALIGNS FEATHERS WITH POLLEN, SAYING "REPEAT THIS MAGIC SONG":

> RUB YOUR FEET WITH POLLEN AND REST THEM.
>
> RUB YOUR HANDS WITH POLLEN AND REST THEM.
>
> RUB YOUR BODY WITH POLLEN AND LIE AT REST.
>
> RUB YOUR HEAD WITH POLLEN AND PUT YOUR MIND
>
> TO REST.
>
> THEN TRULY YOUR FEET BECOME POLLEN.
>
> YOUR HANDS BECOME POLLEN.
>
> YOUR BODY BECOMES POLLEN.
>
> YOUR HEAD BECOMES POLLEN.
>
> YOUR SPIRIT WILL THEN BECOME POLLEN.
>
> YOUR VOICE WILL THEN BECOME POLLEN.
>
> ALL OF YOU IS AS POLLEN IS.
>
> AND WHAT POLLEN IS, THAT IS WHAT PEACE IS.

DINÉ BAHANE': THE NAVAJO CREATION STORY

A KNOT APPEARS IN A CORNER OF THIS *DIYOGÍ*, AND IT RESEMBLES MANY FOUND IN SEVERAL OTHER TEXTILES. SUCH KNOTS ARE ERRONEOUSLY PRESUMED TO BE A PLACE WHERE THE ENDS OF A BROKEN WARP WERE TIED TOGETHER, EVEN THOUGH WARP THREADS RARELY BREAK. SUCH A KNOT, WE LEARNED, OFTEN CONTAINED A SMALL PINCH OF POLLEN. WHOEVER WOVE THIS BLANKET APPARENTLY SOUGHT PROTECTION FOR THE DESIGNATED WEARER.

V. A World in Motion:

Living in a Dynamic Landscape

THE WORLD, WITH ITS CELESTIAL SURROUNDINGS, REMAINS A DYNAMIC PLACE. MOTION IS PART OF EXISTENCE, AND SOMETIMES THE HUMAN *NI'HOOKÁÁ DINÉ'É*, THE FIVE-FINGERED EARTH SURFACE PEOPLE, PARTICIPATE IN THAT MOVEMENT. FOR BETTER OR FOR WORSE, TRAVEL IS NECESSARY; SOMETIMES ONE MUST GO BEYOND THE BOUNDARIES SET BY THE FOUR SACRED MOUNTAINS. JUST AS STARS AND THE CONSTELLATIONS ARE IN MOTION, SO TOO ARE PEOPLE. HORSES AND MOTOR VEHICLES MADE MOVEMENT EASIER BUT NOT LESS RISKY, AND IT IS THE WEAVER'S TASK TO HELP PROTECT A TRAVELER FROM HARM AND EVEN HELP BRING VICTORY TO A RIDER IN A RACE OR RODEO. ACCORDING TO BLESSINGWAY CEREMONY SINGER ERNEST BECENTI, SADDLE BLANKETS AS WELL AS CEREMONIAL RUGS RECORD THE RESPECT AND AFFECTION THAT MAY EXIST BETWEEN WEAVER AND USER.

HUMANS, EVOLVES. EMBEDDED IN THE RUG IS THE FUNDAMENTAL UNITY UNDERLYING THE ENTIRE NEXUS OF NAVAJO STORYTELLING, WHICH TAKES YEARS TO MASTER. WITHOUT ELABORATING, MEDICINE MAN ERNEST BECENTI ADDED THAT IN ADDITION TO SERVING AS A SADDLE BLANKET, THIS ITEM WAS USED IN CEREMONIES BY ITS OWNER. BY SITTING ON IT, HE COULD MAINTAIN A SENSE OF DIRECTION WHILE TRAVELING AND THUS BE ASSURED A SAFE RETURN.

ESSENTIALLY A SET OF CROSSED PERPENDICULARS, THE SYMBOL IMPOSES ORDER ON AN OTHERWISE CHAOTIC EXPANSE OF SPACE BY QUARTERING IT ACCORDING TO THE FOUR CARDINAL DIRECTIONS. A RIGHT-ANGLE EXTENSION FIXED TO EACH OF THE FOUR ENDS INDICATES AN EXTERNAL FORCE. SCHOLARS HAVE RECOGNIZED A CLOSE RELATIONSHIP BETWEEN THE SWASTIKA AND THE *TSIN NÁÁBAŁÍ JINÍ,* OR WHIRLING LOGS, THAT FIGURE PROMINENTLY AS THEMES IN THE MALE SHOOTINGWAY, NIGHTWAY, AND PLUMEWAY CEREMONIES. IN THOSE STORIES A HERO MAKES HIS WAY OR IS INVOLUNTARILY TAKEN TO THE INNERMOST WORLD WHERE FOUR STREAMS JOIN. THE ULTIMATE SOURCE OF MOVEMENT AND GROWTH, IT REPRESENTS AN OMINOUS WHIRLPOOL DESTINATION FOR THE EARTHBOUND TRAVELER. DRIVEN BY THE FOUR DIRECTIONAL WINDS THE TWO LOGS SPIN AROUND ON THE LAKE'S SWIRLING SURFACE.

IF THE HERO SURVIVES, HE ACQUIRES GREAT WISDOM. THE MALE *SA'ĄH NAAGHÁÍ,* OR LONG LIFE, INTERSECTS WITH THE FEMALE *BIK'ÉH HÓZHǪ,* OR HAPPINESS, TO DESIGNATE THE PROCREATIVE FORCE IN THE PERFECT LIFE. THERE, TOO, LIES THE CENTER OF THE INNERMOST WORLD AND THE ULTIMATE SOURCE OF ALL ANIMATION.

DON'T WEAVE THAT DESIGN ANY MORE OR THE SOLDIERS WILL TAKE YOU AWAY.

IF THE BARE, SWASTIKA-LIKE SYMBOL-FIGURE SEEMS STARKLY SIMPLE, ITS COMPLEXITY AS A FUNDAMENTALLY IMPORTANT SYMBOL EMERGES IN SAND PAINTING EFFIGIES OF THE WHIRLING LOGS, SUCH AS THIS RENDERING.

TOLD DURING THE WAR NOT TO USE THE SWASTIKA, MANY WEAVERS STILL EXPRESS AN AVERSION TO THIS ANCIENT SYMBOL. NAVAJOS HAVE ALWAYS BEEN DEEPLY PATRIOTIC, AND ONCE THE IMAGE WAS IDENTIFIED WITH NAZI GERMANY, WEAVERS SHUNNED IT.

THE MEN SEEMED MORE WILLING THAN THE WOMEN TO TALK ABOUT THIS *DIYOGÍ* (DETAIL). IN IT PEACEMAKER RAYMOND JIM RECOGNIZED AN ANCIENT SYMBOL REPRESENTING THE FOUR WINDS MOVING IN FOUR DIRECTIONS. LEON SECATERO REPORTED THAT IT COULD ULTIMATELY BE ASSOCIATED WITH THE PROTOTYPICAL MALE AND FEMALE FROM WHOM ALL LIFE, INCLUDING

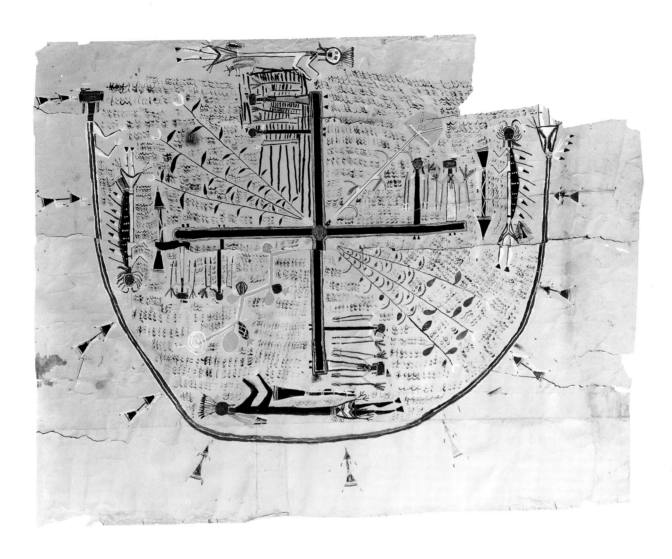

Rendering of Navajo sand painting depicting the Whirling Logs, associated with the Nightway Ceremony; courtesy University of Arizona.

PRAY WHEN YOU GET UP IN THE MORNING IF YOU INTEND TO SET OUT ALONE.

THE DARK STRIPE ALONG THE BOTTOM, THE WEAVERS AGREE, IS THE EARTH, WHILE THE LIGHT PORTION IS THE SKY. THIS PIECE, THEN, IS A TYPICAL DESERT SCENE IN WHICH ONE LOOKS EASTWARD INTO THE DAWN'S LIGHT. AT THE SAME TIME, ADDED WEAVERS LORETTA BENALLY AND MINNIE AND EDNA BECENTI, THE COMBLIKE ARRAY SUGGESTS THE PATTERN FOUND IN THE STOMACH WALL OF A SHEEP. THUS, THE SHEEP'S INNARDS CONVERGE WITH THE EXPANSE OF EARTH AND SKY, WHICH THE TRAVELER MUST NEGOTIATE.

A PIECE OF SINEW (SEE PAGE 11) WAS WOVEN INTO THIS SADDLE BLANKET, PRESUMABLY TO PROTECT THE RIDER. "PRAY WHEN YOU GET UP IN THE MORNING IF YOU INTEND TO SET OUT ALONE," NAVAJOS SAY, FOR A PREVAILING UNCERTAINTY ACCOMPANIES TRAVEL, ESPECIALLY INTO THE ALIEN TERRITORY THAT LIES OUTSIDE THE FOUR MOUNTAINS MARKING THE BOUNDARIES OF *DINÉBIKÉYAH*. WHEN ASKED ABOUT THE SINEW IN THIS PIECE, WEAVER JUNE KALLECO'S EYES LIT UP. "EVEN TODAY," SHE SAID, "SINEW IS PLACED IN THE SADDLE BLANKET OF RODEO HORSES." PROBABLY FROM SOME FAMILY'S FASTEST, STRONGEST HORSE, IT WAS WOVEN IN TO PASS SOME OF THAT STRENGTH TO THE RIDER'S PRESENT MOUNT. "RODEO RIDERS NOW PLACE SUCH THINGS IN THEIR SADDLE BLANKETS," JUNE CONTINUED. WHEN WE TOLD HER ABOUT WHAT LOOKED LIKE A FRAGMENT OF A DOLLAR BILL FOUND IN ONE SADDLE BLANKET, SHE KNOWINGLY REPLIED THAT IT WAS PROBABLY A LITTLE STRIP OF CURRENCY THAT BELONGED TO A CHAMPION RIDER WHO WANTED A PIECE OF HIS WINNINGS WOVEN IN FOR GOOD LUCK.

ITEMS WERE WOVEN INTO RUGS SECRETIVELY; THE WEAVERS DID NOT WANT THEM TO BE SEEN EASILY. "BUCKSKIN IS USED TO PROTECT THE TRAVELER IN A HOLY WAY," JUNE ADDED, NOT ELABORATING EXCEPT TO SAY THAT IT WOULD COME FROM THE SKIN OF A BUCK KILLED IN A RITUAL WAY. ELSEWHERE WE LEARNED OF A SPECIAL PRAYER RECITED BY A TRAVELER WHILE SITTING ON A BUCKSKIN AFTER A SAFE RETURN.

WILLIE BECENTI AND HIS WIFE NELLIE TOLD OF SONGS AND PRAYERS RECITED FOR HORSES AND RIDERS. WILLIE DESCRIBED THE SUCCESS HIS FATHER AND GRANDFATHER HAD WITH THEIR MOUNTS ON LONG CATTLE DRIVES AND IN FIERCE RACES. UPON LEARNING ABOUT THE SINEW IN THIS PIECE, NELLIE TALKED ABOUT USING TISSUE FROM ANIMALS SUCH AS COUGARS, WILDCATS, OR EVEN SQUIRRELS, WHOSE STRENGTH GAVE THEM ADDED QUICKNESS REGARDLESS OF SIZE.

23

DOUBLE-WEAVE SADDLE BLANKET

1940S, 36" X 54"

IN A DYIOGÍ, IT DEPENDS ON WHAT THE
WEAVER WAS THINKING.

THE RANGE OF RESPONSES SUGGESTS SOMETHING VERY
EVOCATIVE IN THIS RARE SPECIMEN OF A DOUBLE-WEAVE SADDLE
BLANKET WITH TWO SUCH DIFFERENT FACES. IT IS AS IF THE
WEAVER PRODUCED SEPARATE ITEMS ON THE SAME LOOM AT THE
SAME TIME, AND TWO DISTINCT IDEAS, OR CONCEPTS, MERGE IN
THE NAVAJO MANNER OF ALL-ENCOMPASSING SYNTHESIS.

WHILE ALL GENERALLY AGREED THAT THE FACE WITH THE
WHITE BACKGROUND REPRESENTED A RAINBOW, THOSE WHO SAW
THIS ITEM DIFFERED IN THEIR RESPONSE TO THE OPPOSITE FACE.
THE MIDDLE FIGURES, FOR EXAMPLE, WERE VARIOUSLY IDENTIFIED
AS NUMERICAL SYMBOLS, AS CEREMONIAL MALE AND FEMALE
EFFIGIES, AND AS LIFELINES, WITH THE TWO STRAIGHT STEMS REP-
RESENTING CHILDHOOD AND OLD AGE, WHOSE OPTIONS ARE FEW,
AND THE CIRCULAR SHAPE SIGNIFYING PRIME ADULTHOOD WITH
ITS MANY OPTIONS.

"IT DEPENDS ON WHAT THE WEAVER WAS THINKING," CAU-
TIONS MEDICINE MAN ERNEST BECENTI, REMINDING US THAT
SADDLE BLANKETS WERE MOST FREQUENTLY WOVEN FOR PERSON-
AL USE, NOT FOR THE MARKET, AND THAT THEY OFTEN REFLECT THE
QUIET SENTIMENTS OF THE WEAVER. A TRADER'S DEMANDS DID
NOT MATTER, LEAVING A WEAVER TO CONSIDER HER OWN
THOUGHTS AND IMPRESSIONS. THE NAVAJO VISION DISPLAYS
ITSELF ABSTRACTLY IN THE WAY THE DESIGN VARIES AND MORE
CONCRETELY IN CERTAIN FIXED SYMBOLIC ELEMENTS.

IN THIS PIECE, ONE NOTICES A GREAT DEAL OF DYNAMISM
WITHIN THE ARRANGEMENT OF THE DIAGONAL DIAMONDS.
NOTE ALSO HOW THE WARP EDGES DIFFER FROM ONE SIDE TO
THE OTHER. MOVEMENT AND CHANGE ABOUND IN WHAT THE
TRAVELER SEES ALONG THE WAY, IN PROGRESS ALONG THE TRAIL,
IN LIFE'S PASSAGE, IN THE EVER-SHIFTING LIGHT. THERE IS NO
PLACE FOR FIXED SYMMETRY IN THE WORLD.

MANY IDENTIFIED IN THIS BLANKET THREE PRIMARY NAVAJO
COLORS: RED FOR THE FEMALE EARTH; WHITE FOR THE MALE SKY;
AND BLACK FOR THE RAIN. UNDERLYING THEIR VARIOUS INTER-
PRETATIONS, MOST AGREED THAT THE TWO CENTRAL IMAGES SIG-
NIFY UNITY—THE UNION OF MALE AND FEMALE, OF PEOPLE AND
ANIMALS, OF THE *DIYIN DINÉ'É*. THE HOLY PEOPLE, WITH THE
NI'HOOKÁÁ DINÉ'É, THE EARTH SURFACE PEOPLE, AND OF ALL OF
EARTH'S INHABITANTS WITH THE SURROUNDING SKY—RESULTING
FROM AN EVER-CHANGING WORLD IN A DYNAMIC UNIVERSE.
HELPED BY THEIR COMMENTS, WE ASSOCIATE THE DIAGONALS
WITH PASSAGE TO AND FROM THE SKY, WHERE THE TWINS ASKED
THEIR FATHER *JÓHONAA'ÉÍ*, THE SUN, FOR WEAPONS TO FIGHT THE
MONSTERS. INDEED, EACH INDIVIDUAL VENTURE AWAY FROM
HOME OR BEYOND THE BOUNDARIES OF THE FOUR SACRED
MOUNTAINS IS A PERSONAL REENACTMENT OF THAT SKYWARD
JOURNEY, AND BY ASSOCIATION A REITERATION OF THE LONG
WALK AND ITS CONCLUSION OF RETURN AND REVIVAL.

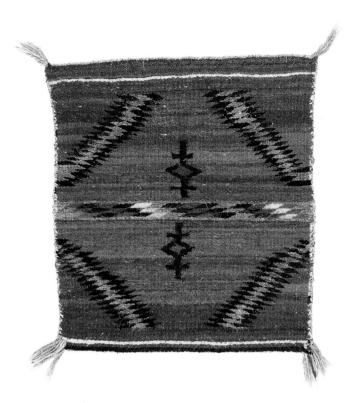

24

SMALL DOUBLE-WEAVE SADDLE BLANKET

N.D., 25" x 27"

A WEAVER'S GOOD THOUGHTS GO WITH THE HORSE AND RIDER.

NEITHER ROLAND MITCHELL NOR HIS BROTHER BLACKHORSE MITCHELL HAD SADDLES WHEN THEY WERE LEARNING TO RIDE. THEY SIMPLY RODE BAREBACK AND WORKED THE MANE TO CONTROL THE HORSE. RIDER AND HORSE WERE ONE. WEAVERS BECAME AWARE OF THE NEED FOR SADDLE BLANKETS WITH THE ARRIVAL OF THE SADDLE; WITH SADDLE BLANKETS, THEY HOPED TO PROTECT THE HORSE AND ADD TO THE PRIDE OF OWNING ONE THAT PERFORMED WELL.

THE FRINGE ON THIS COLORFUL SADDLE BLANKET IS PLACED TO THE REAR AND IS DISPLAYED PROUDLY, BLACKHORSE TELLS US, "LIKE THE FEATHERS OF A BIRD'S TAIL." THE BRIGHT COLORS COME FROM NATURAL DYES. THE REPEATED STRIPES AND ARROW POINTS SUGGEST ABUNDANCE, WHICH A FAST HORSE COULD PROVIDE BY WINNING RACES. THE MARKED CONTRAST BETWEEN THE BROAD CHEVRONS ALONG THE FRINGE EDGE AND ITS OPPOSITE COUNTERPART UNDERSCORES THAT ABUNDANCE. THE VARIATION FROM THE FRONT HALF OF THE SADDLE BLANKET TO THE REAR IS QUITE CHARACTERISTIC. ONLY WHEN THE TRADERS PROVIDED A MARKET FOR TEXTILES DID WEAVERS BEGIN TO STRIVE FOR FULL SYMMETRY IN TEXTILES.

WOVEN INTO ONE CORNER AND PLACED THERE IN ALL LIKELIHOOD TO GIVE THE MOUNT THE SPEED AND STRENGTH OF A BIRD IN FLIGHT IS A SMALL TUFT OF FEATHER. EMMA MITCHELL, MOTHER OF BLACKHORSE AND ROLAND, VERIFIED THAT WEAVERS DELIBERATELY WORKED ITEMS SUCH AS FEATHERS INTO SADDLE BLANKETS FOR A REASON. HORSEHAIR MIGHT BE SPUN INTO THE YARN TO ADD STRENGTH TO THE WARP, OR THE HAIR FROM THE MANE OR THE TAIL OF A FAVORITE HORSE MIGHT BE WOVEN INTO THE WEFT OF A SADDLE BLANKET TO GIVE STRENGTH AND SPEED TO ANOTHER HORSE. "REMEMBER," CAUTIONED ONE WEAVER, "BACK THEN THE HORSE WAS THE PRIMARY MEANS OF TRAVEL, WHICH COULD BE FRAUGHT WITH DANGER. WITH HER GOOD THOUGHTS, A WEAVER COULD HELP PROTECT THE RIDER."

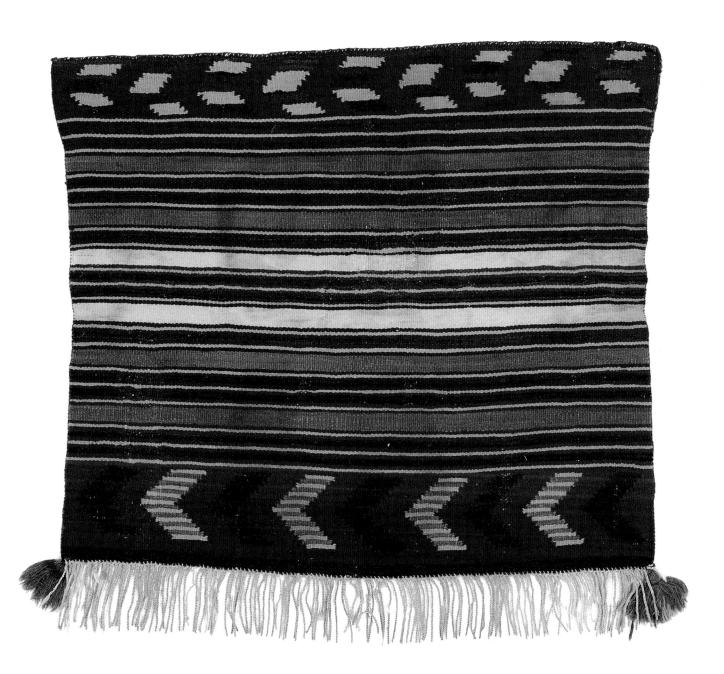

25
SADDLE BLANKET

1870s, 29" x 24"

THIS WEAVER EVOKES THE JOURNEY OF
THE TWINS.

FEW PIECES ELICITED MORE COMMENT OR GREATER PRAISE
OF WORKMANSHIP THAN DID THIS BLANKET. EVERYONE WHO SAW
IT ADMIRED THE TIGHTNESS OF ITS WEAVE, THE DETAILED INTRICA-
CY WOVEN INTO WHAT AT FIRST LOOKS LIKE A MERE TWILL, AND
FINALLY THE EXTENT OF THE WEAVER'S KNOWLEDGE OF THE TRA-
DITIONAL WAYS.

THIS PIECE TAUGHT US TO SEE BEYOND TECHNIQUE; IT
PROMPTED US TO SEEK THOUGHTS AND CONCEPTS. ACCUSTOMED
TO HEARING THAT WEAVERS MADE MISTAKES LEADING TO "IMPER-
FECTIONS," WE COULD NOT ACCEPT THE APPARENT IRREGULARITIES
HERE AS JUST THAT. THIS WEAVER HAD APPLIED MUCH MASTERY;
SOME FUNDAMENTAL PATTERN HAD TO BE AT WORK, EXPRESSING
A DEEP UNDERSTANDING OF NATURE'S CYCLES, AN AWARENESS
OF STRUCTURE IN THINGS MAN-MADE AND THOSE NATURALLY
CREATED, AND A GRASP OF THE UNDERLYING UNITY IN WHAT
ONLY SEEMED DISORDERLY. IN SCRUTINIZING ITEMS SUCH AS THIS
ONE, THE STRUCTURE OF A STORY'S PLOT OR THE SEQUENCE OF A
PRAYER HAD TO BE
CONSIDERED.

WHEN HE EXAMINED THIS SPECIMEN, LEON SECATERO
REPORTED THAT THE RED SPECKS WOVEN INTO IT DESIGNATE A

JOURNEY ANALOGOUS TO THAT OF WARRIOR TWINS AND TO JOUR-
NEYS DESCRIBED IN OTHER STORIES. ACCORDING TO LEON, THIS
SADDLE BLANKET IS FULL OF SONGS AND PRAYERS KNOWN TO THE
WEAVER. THERE APPEARS TO BE NO FIXED SCHEME OF VARIATION
AT FIRST UNTIL THE SETS OF REPEATED ROWS ARE MATCHED WITH
CHANTWAY PRAYERS IN WHICH LINES ARE REPEATED IN VARYING
SEQUENCES OF THREE OR FOUR OR FIVE. WHEN WEAVER ANNA
MITCHELL FROM LITTLE WATER, NEW MEXICO, SAW THIS BLANKET,
SHE AGREED THAT THE VISUAL RHYTHM OF THE RUG COULD
INDEED MATCH THE AURAL RHYTHM OF A PRAYER.

MAGNIFICATION REVEALED A PIECE OF FOREIGN MATTER
ALONG WITH A NUMBER OF POLLENLIKE PARTICLES WOVEN INTO
THE BLANKET. CLEARLY, THE WEAVER INTERWOVE THESE ITEMS BUT
WANTED THEM TO EXIST UNSEEN. UNDER ELECTRONIC MAGNIFI-
CATION WE FOUND THAT A GLUELIKE ADHESIVE WAS EVIDENTLY
USED TO KEEP SUCH ITEMS IN PLACE. THE ELDERS, RELUCTANT TO
ELABORATE, SAID THAT WHAT A WEAVER INSERTED WAS PERSON-
AL AND PLACED THERE FOR "PROTECTION." THIS ENGLISH WORD
COVERS A NUMBER OF MEANINGS THAT TOGETHER REFER TO THE
ONGOING STRUGGLE TO BALANCE INTERNAL HARMONY WITH
GREATER EXTERNAL HARMONY.

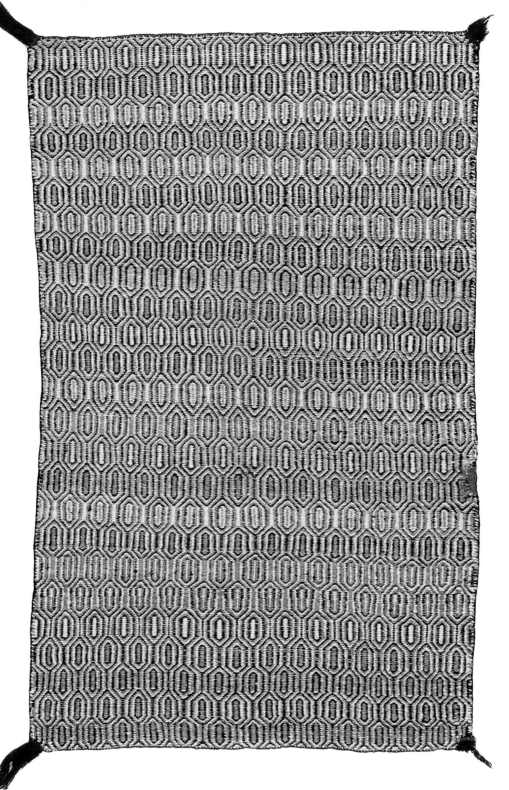

26

Manta or Blanket

(probably ceremonial)

1875-80, 56" x 93"

MYSTERY CAN EMANATE FROM A
DAH'IISTL'Ó ALONG WITH ITS BEAUTY.

WHEN WEAVER PRISCILLA PETTIGREW FROM PUEBLO
PINTADO, NEW MEXICO, SAW THIS PIECE, SHE ASSOCIATED THE
NATURAL BROWN WITH PRAYERS AND THE DIAMOND STRIPES
WITH A PATHWAY OR TRAIL A MAN WOULD TAKE ON A JOURNEY
OR A RAID. ALLUDING TO THE DANGERS OF TRAVELING DURING
TIMES OF WARFARE, SHE SPECULATES THAT THIS BLANKET WAS TO
BE USED IN A CEREMONY OF DEPARTURE AND RETURN, PERHAPS
AN ENEMYWAY CEREMONY.

FULL OF WOVEN-IN PARTICLES, IT EXPRESSES CONCERN FOR
THE TRAVELER. IN ADDITION TO A PROBABLE POLLEN KNOT SLIGHT-
LY MORE THAN FOUR INCHES UP FROM ONE SELVAGE AND
ANOTHER ON THE OPPOSITE FACE AND AGAINST THE OTHER WARP
SELVAGE, IT CONTAINS A SEEDLIKE OBJECT, WHAT MAY BE A SLIV-
ER OF CORNHUSK, A SMALL PIECE OF SINEW OR ANIMAL TISSUE,
SEVERAL STRANDS OF COTTON STRING, A PIECE OF FEATHER, AND
A THIN STRAND OF WHAT IS PROBABLY HORSEHAIR OR PERHAPS
EVEN HUMAN HAIR. PRISCILLA INDICATED THAT THE PARTICLES,
WHICH ARE SCARCELY VISIBLE, WERE IMPLANTED SECRETLY FOR
PROTECTION. THEY ARE TO BE UNOBTRUSIVE.

SOMEWHAT YOUNGER THAN THE CROWNPOINT WEAVERS,
PRISCILLA SEEMED LESS TROUBLED BY THIS RUG THAN THE OTH-
ERS WERE WHEN THEY EXAMINED IT. VERIFYING THAT IT BELONGS
TO THE ENEMYWAY CEREMONY, JUNE KALLECO RECOGNIZED THE
FEATHER AS THAT OF AN EAGLE AND THE COLORED YARN ALONG

THE EDGES AS THOSE USED IN THE PRAYERSTICKS FOR THAT CERE-
MONY. AS THEY DID WITH PLATE 12, THE ELDERS BACKED AWAY
FROM THIS BLANKET WHEN THEY SAW IT. ONE PARTICLE IN PAR-
TICULAR, DECOMPOSED ANIMAL TISSUE, WAS ESPECIALLY TROU-
BLING TO THEM.

ONCE THEY ARE OVER, LITTLE CAN BE SAID ABOUT RAIDS OR
HUNTING FORAYS THAT OCCUR IN IMPROPER CONTEXTS OR IN
NONCEREMONIAL SETTINGS. KNOWING WHAT HAS BEEN WOVEN
INTO THIS DIYOGÍ AND UNDERSTANDING ITS CEREMONIAL ASSOCI-
ATIONS CONTRIBUTE AN AURA OF MYSTERY WE CAN MATCH WITH
THE WAY ITS DESIGN SHIFTS PROGRESSIVELY. OBSERVE THE CON-
TRAST BETWEEN BORDERS ALONG THE TWO WARP EDGES, THE
RESPECTIVE NATURAL-BROWN BANDS THAT SEPARATE EACH OF
THE ADJOINING BANDS OF DIAMONDS, THE VARIATION ALONG THE
WEFT EDGES IN THE TWO OUTER BANDS, AND THE VISUAL RHYTHM
CREATED BY THE ROWS OF DIAMONDS IN THE MEDIAL BAND.
INDEED, A JOURNEY OR A PROGRESSION BECOMES EVIDENT,
ALONG WITH AN AWARENESS THAT JÓHONAA'ÉÍ, THE SUN, MAKES
A DAILY JOURNEY OVERHEAD EACH DAY WHILE ASDZÁÁ NÁDLEE-
HÉ, THE CHANGING WOMAN, AWAITS HIS RETURN. AS EACH SEA-
SON CHANGES, HIS COURSE ALTERS AND SHE MARKS ITS
PROGRESS. MEANWHILE, THE WEFT BUILDS SKYWARD ALONG THE
WARP IN YET ANOTHER KIND OF PROGRESS. IN UNENDING CYCLES
OF BIRTH AND PASSAGE TOWARD DEATH, EACH LIFE TAKES ON A
MOTION OF ITS OWN TO MATCH THAT OF THE WEAVER AT HER
LOOM, THE SURFACE WORLD, AND THE SURROUNDING COSMOS.

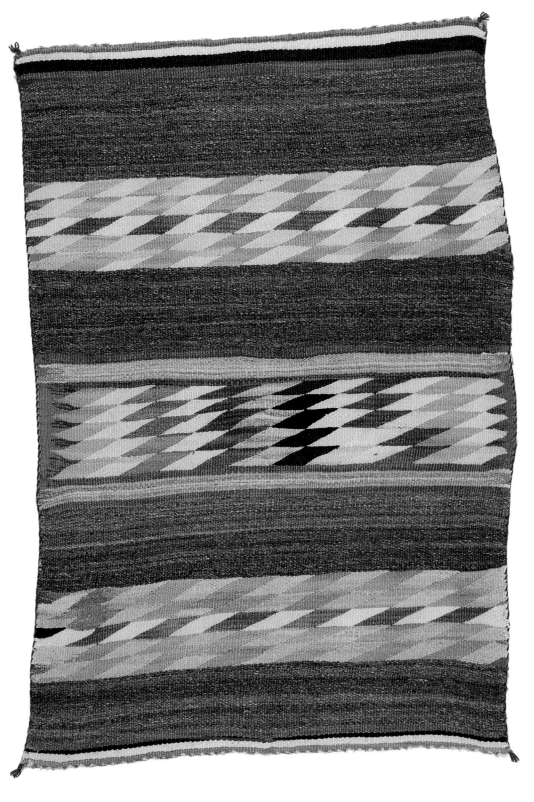

27

BLANKET

(PROBABLY CEREMONIAL)

N.D., 35" x 52"

THE FOLLOWING *DAH'IISTŁ'Ó*—NOT MENTIONED IN OUR DIS-
CUSSION—REPRESENT WHAT CURATORS, DEALERS, AND BUYERS
HAVE GENERALLY ADMIRED ABOUT NAVAJO RUGS WITHOUT LINK-
ING THEM WITH THE STORIES AND CEREMONIES OR LISTENING TO
WHAT ELDERS HAVE TO SAY. THEIR ALLURE COMES INSTEAD FROM
UNASSOCIATED ELEMENTS OF WORKMANSHIP, COLOR, AND DESIGN
THAT APPEAL TO WESTERN TASTES.

SELECTED BY MUSEUM OF INDIAN ARTS AND CULTURE
DIRECTOR BRUCE BERNSTEIN AS STANDARD-BEARERS OF SUCH
ADMIRATION, THEY ARE INDEED STRIKING. THE NAVAJO PERSPEC-
TIVE, HOWEVER, GREATLY INCREASES THEIR APPEAL. TO THE CON-
VENTIONAL WAY OF ENJOYING THEM, ADD WHAT THE STORIES AND
CEREMONIES CONTRIBUTE TO NAVAJO LIFE, EVEN TODAY, OR HOW
WEAVERS HAVE TRADITIONALLY REGARDED THE OVERALL PROCESS
AS ONE THAT BEGINS WITH SHEEP, INCORPORATES THE MYTHIC AND
HISTORIC PAST, AND INCLUDES THE OVERALL ENVIRONMENT.

THE MARK OF A TRULY STRIKING RUG, WE HAVE FOUND, IS
NOT ITS "PERFECTION" OR ITS UNASSOCIATED WORKMANSHIP. ITS
FASCINATION COMES INSTEAD FROM THE WAY IT INVOKES KNOWL-
EDGE AND AROUSES QUESTIONS THAT INVITE REEXAMINATION.
WHICH EDGE MIGHT BE THE DAWN SIDE? WHAT ARE THE PROPER-
TIES OF ITS ASYMMETRY? WHAT OTHER COMPONENTS OF ITS
DYNAMIC TENSION EXIST? WHERE ARE THE NONWOOL FIBERS OR
OTHER FOREIGN MATTER? AT WHAT POINT DOES A SEEMINGLY
ABSTRACT DESIGN DESIGNATE A STORY OR CONNECT WITH LAND
AND SKYSCAPE? SUCH CURIOSITY REWARDS YET ANOTHER LOOK
WITH NEW DISCOVERIES ABOUT A GREAT CULTURE WHOSE WISDOM
IS SHARED THROUGH ITS ART.

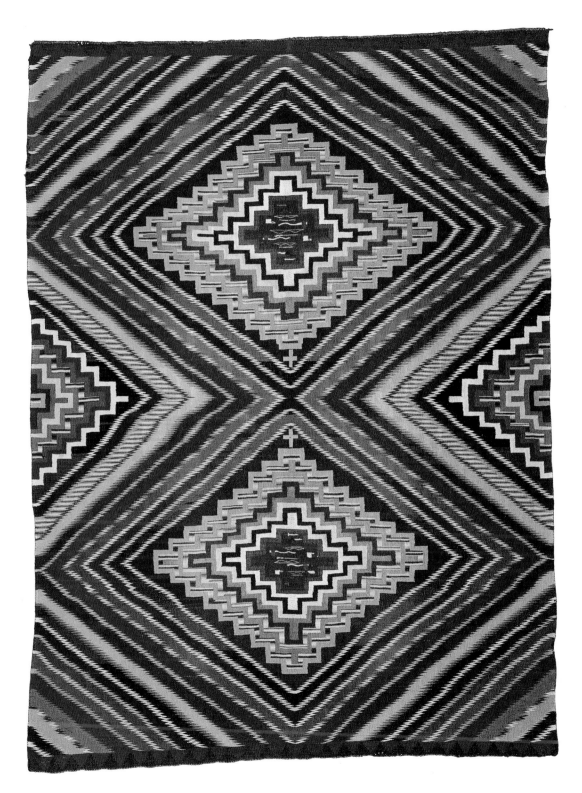

28

BLANKET (GERMANTOWN)

CA. 1900

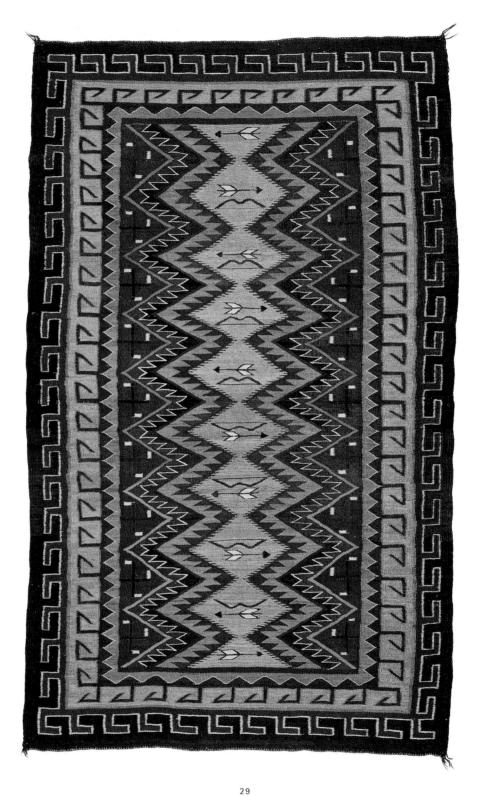

29
Rug (regional?)

N.D.

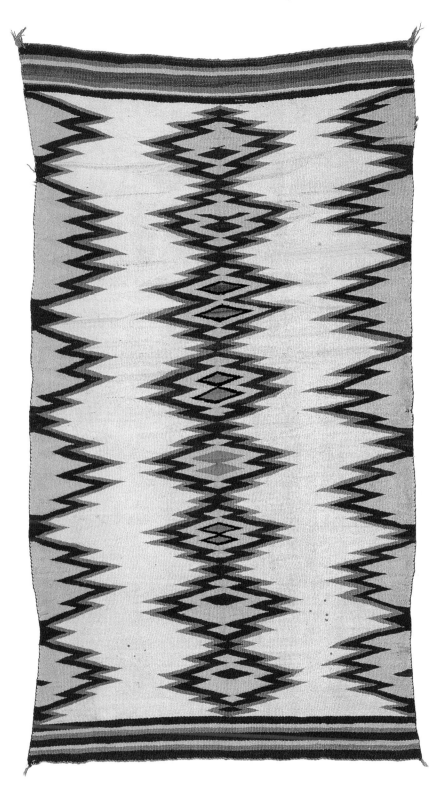

30

BLANKET (TRANSITIONAL)

CA. 1865-90

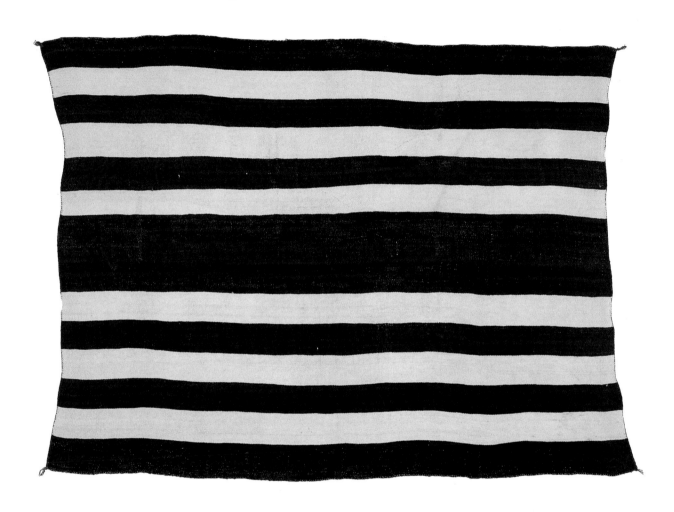

31
BLANKET (PHASE I)

CA. 1800-50

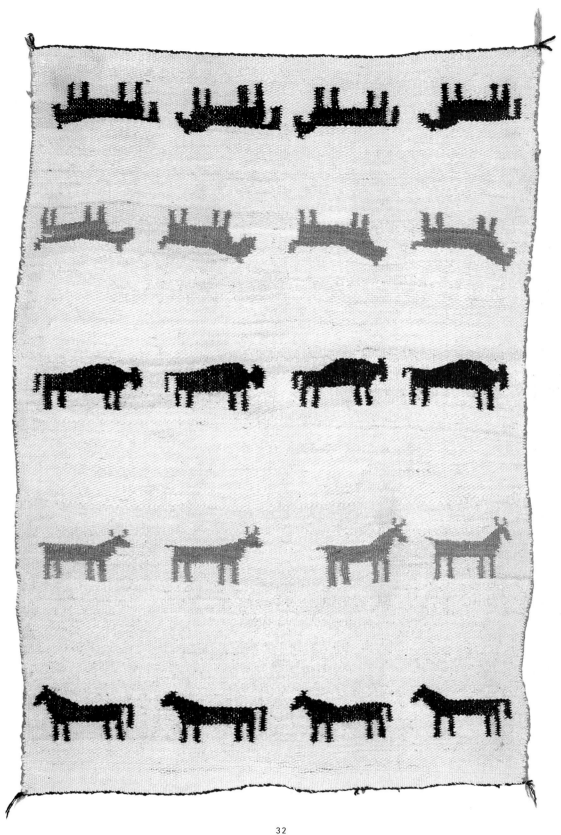

32

RUG (PICTORIAL)

CA. 1880–90

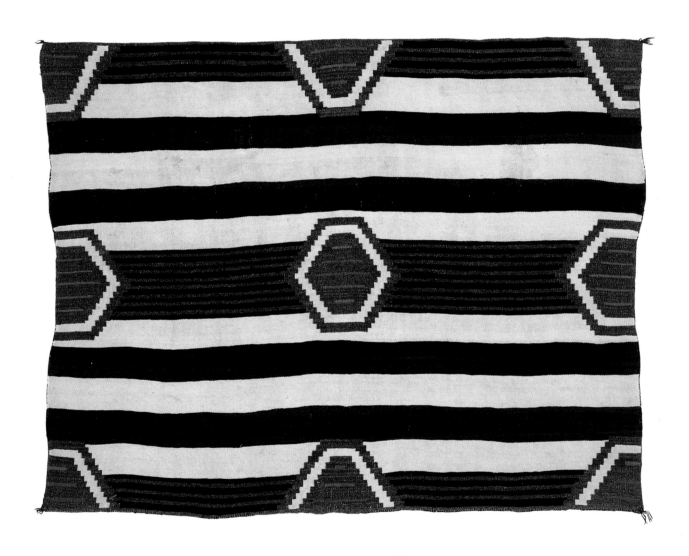

33

CHIEF'S BLANKET (PHASE III)

CA. 1860–80

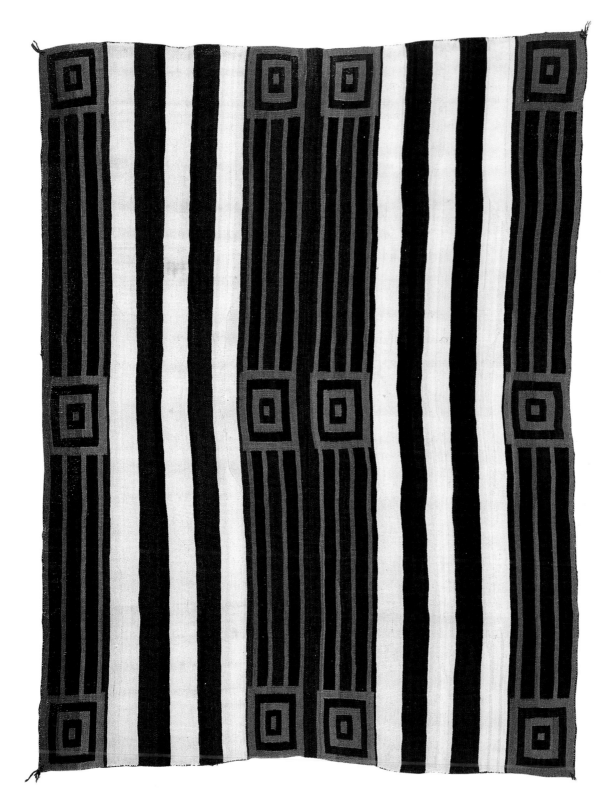

34

WOMAN'S BLANKET (PHASE II–III)

CA. 1880

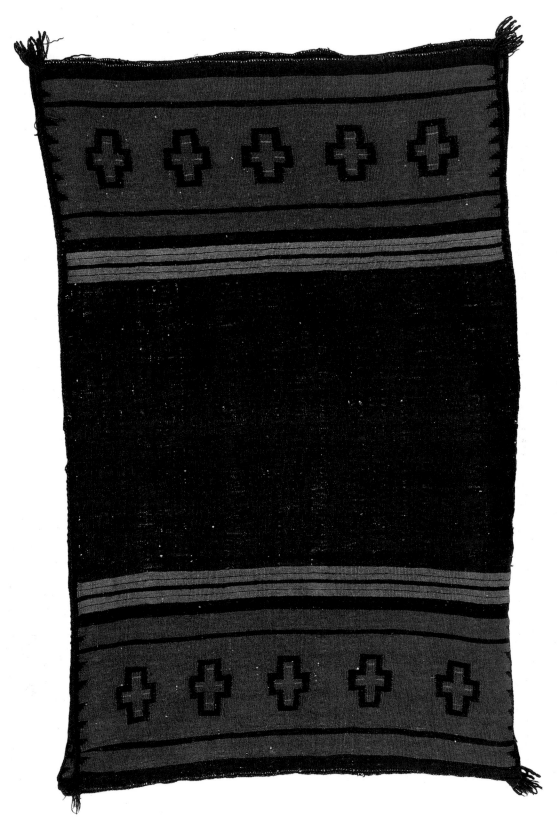

35

MANTA (DRESS OR SHOULDER ROBE)

EARLY 1800S

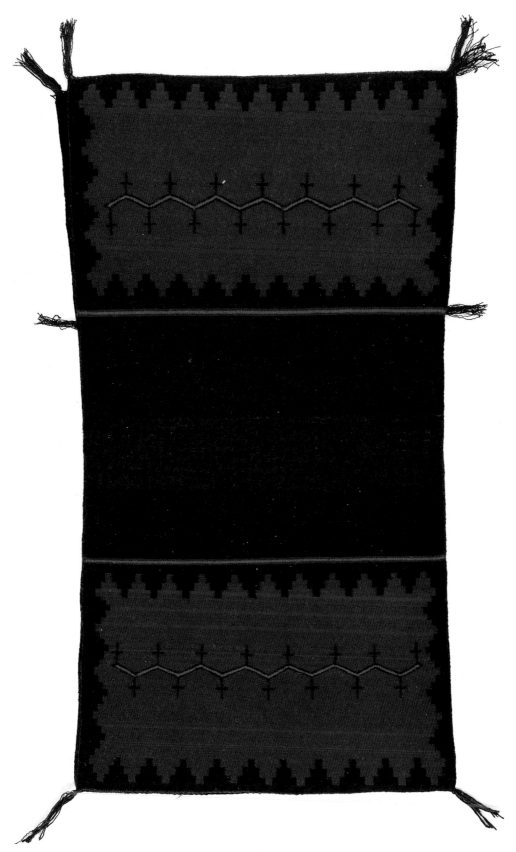

36

Manta (dress or shoulder robe)

POST-1960

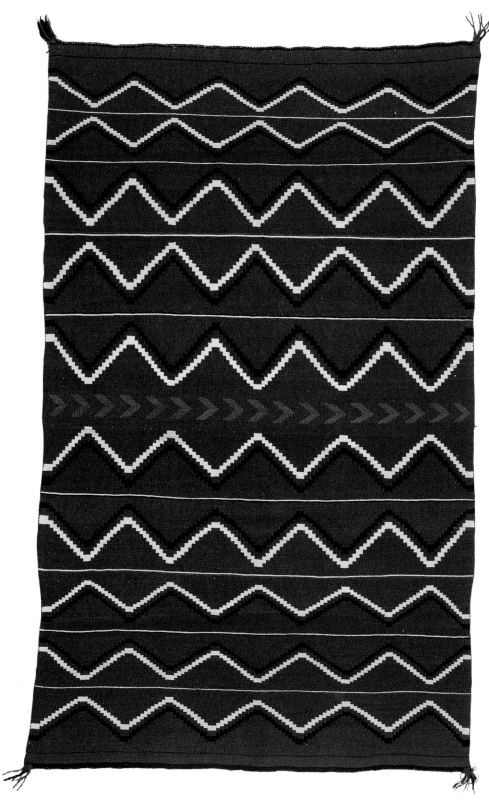

37

Late Classic Serape

ca. 1875–80

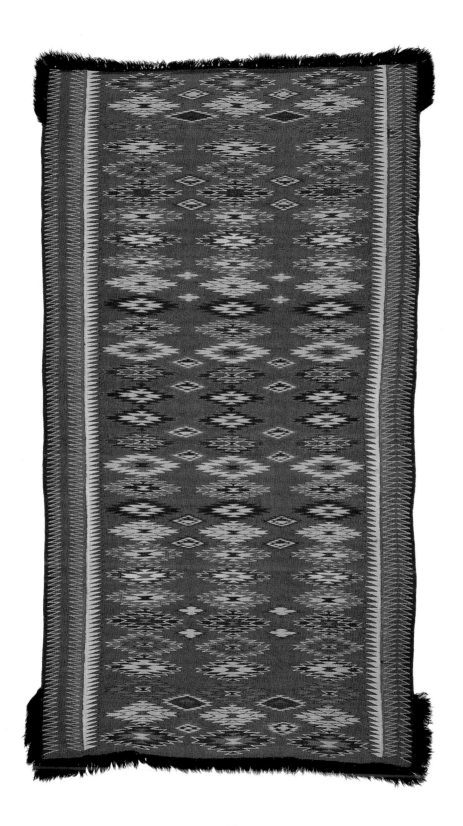

38

RUG (GERMANTOWN)

CA. 1890-1900

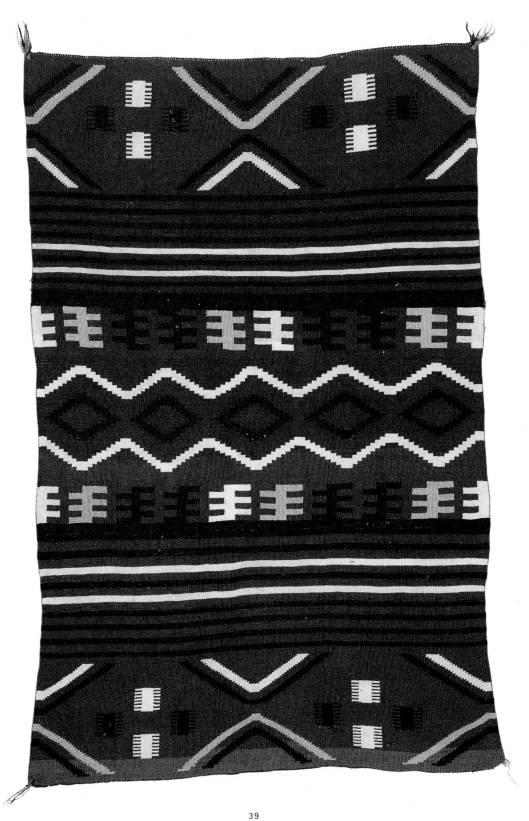

39

CHILD'S SADDLE BLANKET

N.D.

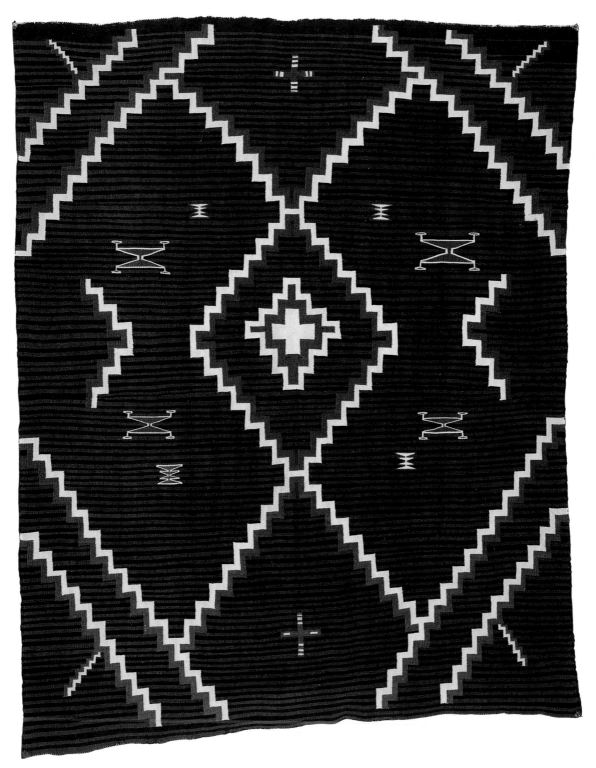

40

BLANKET (HUBBELL)

CA. 1880-90

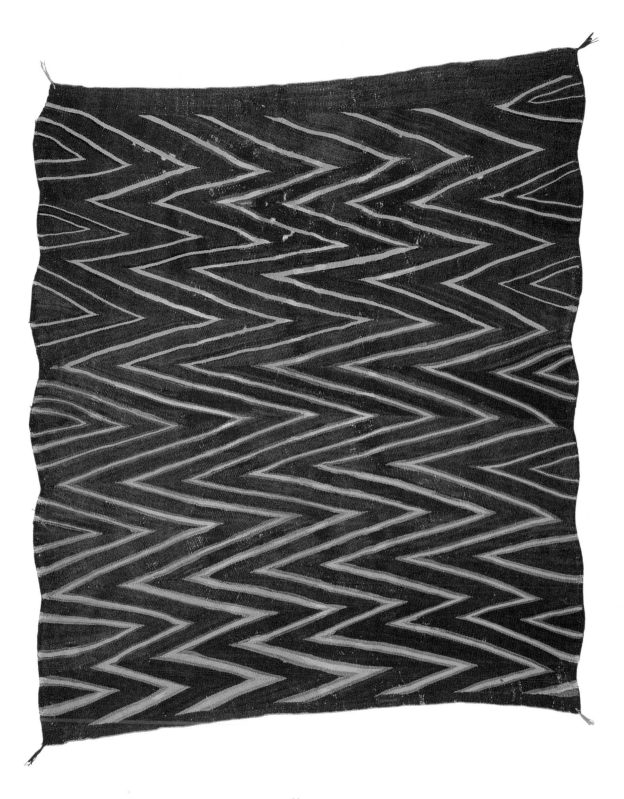

41

WEDGE-WEAVE BLANKET

CA. 1880-90